* *

UNDER *the* DOME

* *

THE VIEW FROM THE CENTER
OF AMERICAN DEMOCRACY
WITH CAPITOL HILL'S SOURCE FOR NEWS

✦ ✦

UNDER *the* DOME

✦ ✦

JASON DICK, Managing Editor of **Roll Call**

Guilford, Connecticut

An imprint of The Rowman & Littlefield Publishing Group, Inc.
4501 Forbes Blvd., Ste. 200
Lanham, MD 20706
www.rowman.com

Distributed by NATIONAL BOOK NETWORK

© 2018

British Library Cataloguing in Publication Information available

Library of Congress Cataloging-in-Publication Data available

ISBN 978-1-4930-3063-7 (hardcover)
ISBN 978-1-4930-3062-0 (e-book)

♾™ The paper used in this publication meets the minimum requirements of American National Standard for Information Sciences—Permanence of Paper for Printed Library Materials, ANSI/NISO Z39.48-1992.

Printed in the United States of America

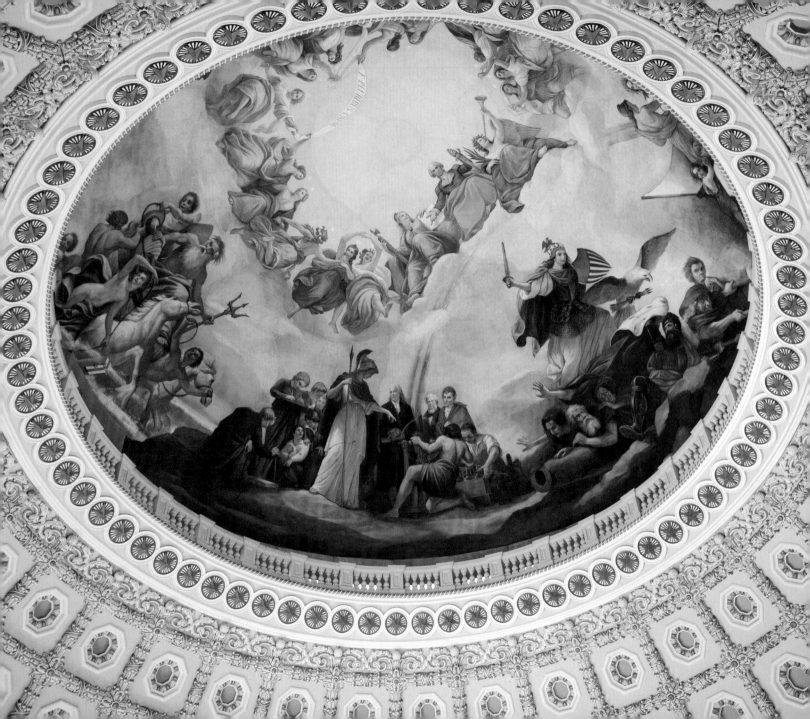

Congress, for better or worse, and sometimes both, is truly representative of the American people.

It's a look into the American public—its hopes, fears, wishes, and gripes, and pretty much everything else.

There's a lot going on there. The American experiment is one of trying to get things right, but acknowledging that we fall short sometimes.

And the United States Capitol is where a whole mess of contradictory feelings come together in, yes, Congress.

That's an interesting word for it: congress.

In addition to Congress being a word for a representative legislative body, it also means a coming together, or meeting.

Far from an abstraction of political views, slogans, and insults, all churned up and culminating in a vote sometime or other, Congress and the Capitol it is housed in is one mixed up place—in a good way.

It's a place to argue, to agree, to protest, to look at incredible art, to see old friends, to make new ones, to make a point.

So people come to the Capitol and Washington for a reason.

You don't get here by accident. You have to want it.

The people who come here want to do something, make the world a better place, see the country's history up close, make a voice heard—for human rights, better health care, lower taxes.

Take your pick. People do.

That goes for both the loftiest president and the humblest tourist.

But that doesn't mean people don't bring their baggage along.

They can be driven, angry, happy, purposeful. It's a wide range of emotions you experience at the seat of government. A petty fight can take place amid reminders of our better selves, like a person who stood up for others, or among reminders of our darkest hours, of war and bondage, and how we got out of them.

Nearly twenty-seven thousand people work for the legislative branch of the United States, from the Speaker of the House to the Architect of the Capitol's groundskeepers.

They are joined every year by millions of visitors. Not many workplaces are also tourist destinations that house museums, monuments, art galleries, and several libraries.

This big old world under the Capitol Dome is what Roll Call, the publication I work for that has been chronicling Capitol Hill and its denizens since 1955, tries to make sense of. We love the politics and the policy. The arguments and the art. The popes and protesters. It's what makes it such a special place.

Our photographers are also in a special place to record this range of human activity and emotion.

Putting together a book of collected images from our decades-long history of covering Capitol Hill poses a big challenge: How to narrow it down? How to reflect our own approach to keeping a journal here? How to get people to take a look, check it out, and feel like, yeah, that's pretty cool, interesting, fun, sad.

In the case of this volume, I thought the way to go was to use the images to portray how rich a world the Capitol is through the range of feelings that people have.

The place can inspire awe on one hand, anger on the other. It can surprise you, and it can fill you with contempt. In some cases, it can scare the hell out of you, like when it is attacked, when people come to do harm. But it can bring out joy as well, and admiration and optimism, especially when we celebrate our heroes and mentors and inspirations.

That's why this book is broken down along fifteen basic emotions, the kind most people experience as a part of their lives.

Some of it will bring a smile, and some of it might move you to tears. It might even happen in the same section.

We don't shy away from humor, but we also don't look away from horror. It's our job to see it all.

The Capitol Dome is one of those instantly recognizable things in the world. You see it, and it means the United States, and Washington, and government. Most everyone has some familiarity with it.

What might not be familiar are the humans and the inside workings of that Dome, the people and things and stuff that make it tick.

There is a lot going on under the Dome.

Check it out.

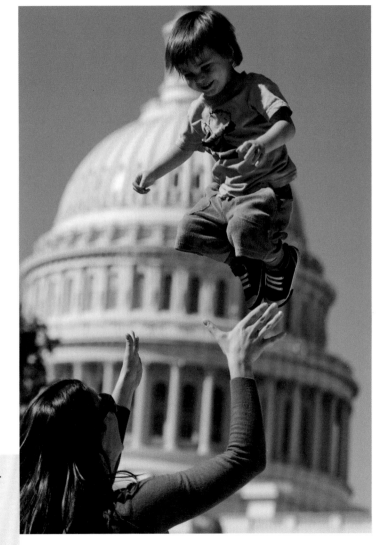

Holly Brown of Capitol Hill tosses her son Oliver into the air on the East Front of the Capitol.
(Tom Williams)

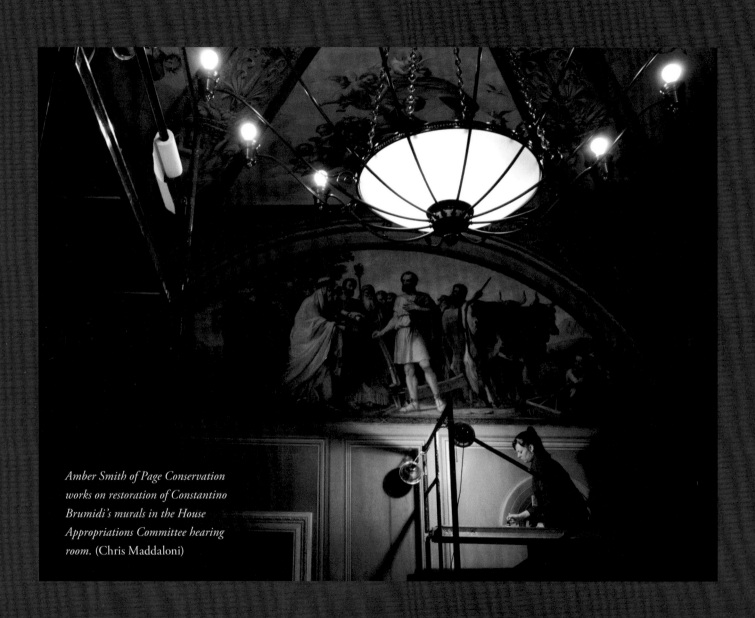

Amber Smith of Page Conservation works on restoration of Constantino Brumidi's murals in the House Appropriations Committee hearing room. (Chris Maddaloni)

Awe

Look up.

You are surrounded by hundreds of tons of iron, marble, and tourists.

You are in the United States Capitol Rotunda, right under the Dome, and there are paintings and rope lines and statues and the bustle of a big government workplace combined with the busy-ness of a big-attraction museum.

Look up.

One hundred and eight feet above the Rotunda floor is Constantino Brumidi's masterpiece fresco, *The Apotheosis of Washington*, the nineteenth-century Italian classicist's rendering of George Washington's journey to the afterlife.

It was placed there, the very tip-top of the ceiling of the seat of representative democracy, up there high, in the eye of the Capitol Dome, a reminder of the great American experiment—idealistic, grandiose, messy, hard-fought, hard-won to all those underneath, be they members of Congress, staff, lobbyists, visitors, police officers, presidents, or popes.

It sets the tone for the Capitol—that everything that happens in and around it, we're all here and part of something much bigger than ourselves.

Now look around.

These kinds of reminders are everywhere—that you are in the presence of something significant, as everyone gets to the business of establishing, every day, a more perfect union.

★ ★

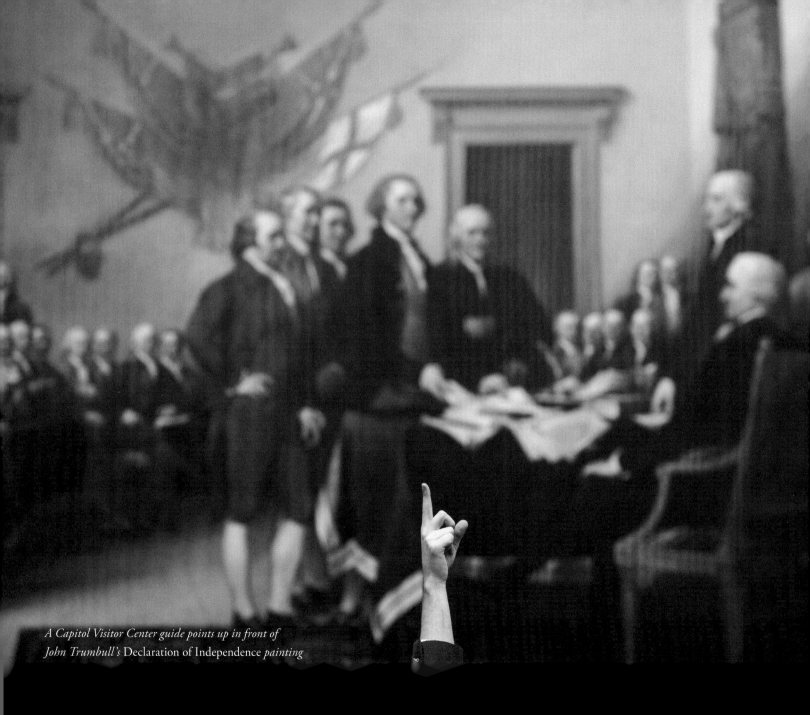

A Capitol Visitor Center guide points up in front of
John Trumbull's Declaration of Independence *painting*

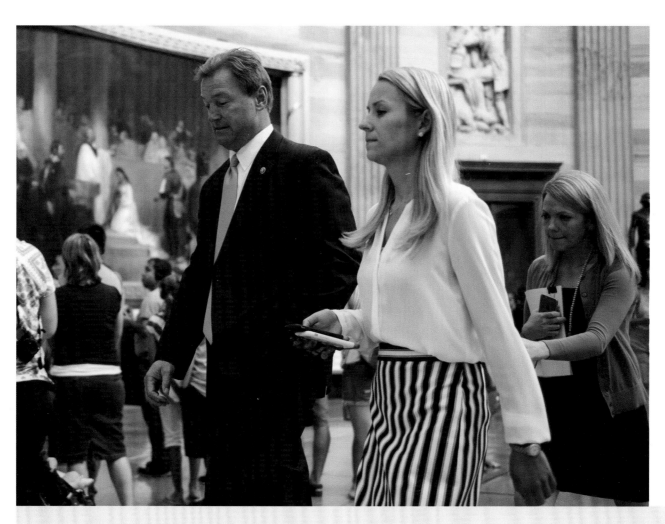

Sen. Dean Heller, R-Nev., walks through the Capitol Rotunda on a busy Tuesday. (Bill Clark)

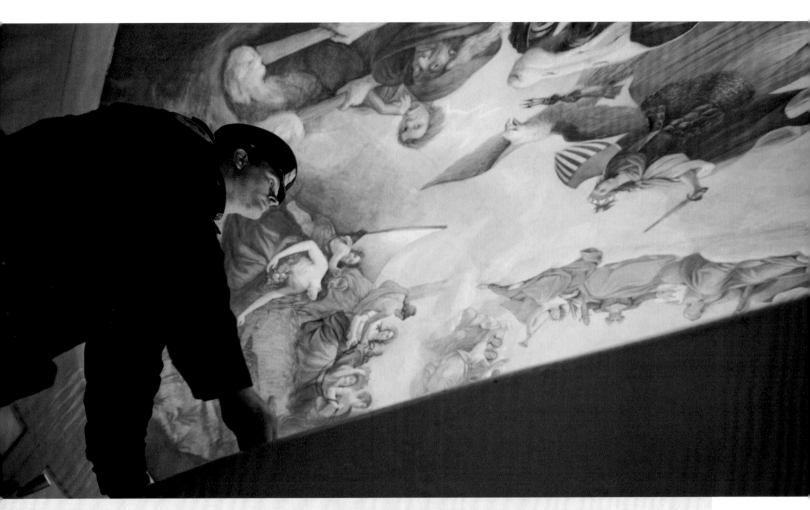

Capitol police officer Adam Taylor checks out Constantino Brumidi's fresco The Apotheosis of George Washington *on the ceiling of the Capitol Dome.* (Douglas Graham)

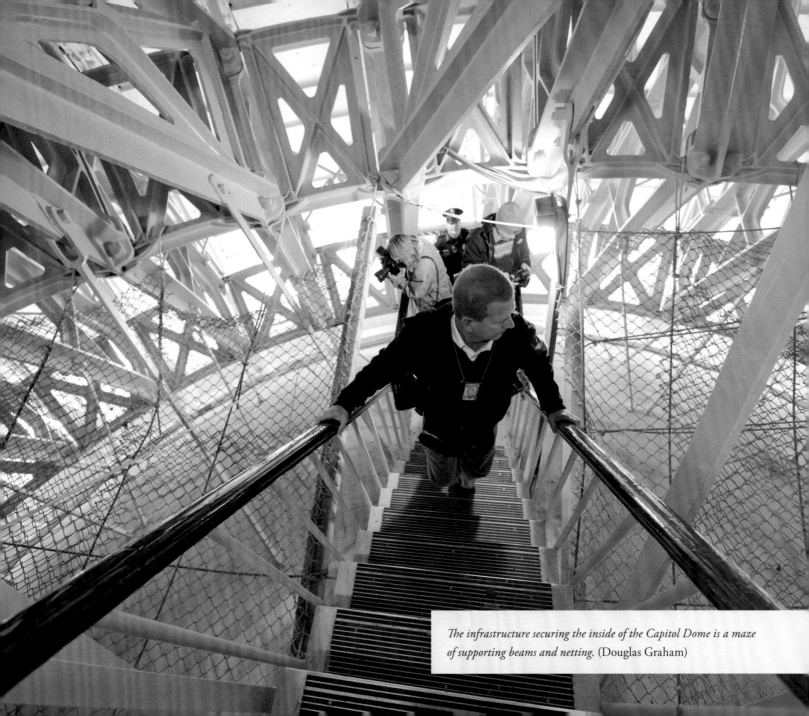

The infrastructure securing the inside of the Capitol Dome is a maze of supporting beams and netting. (Douglas Graham)

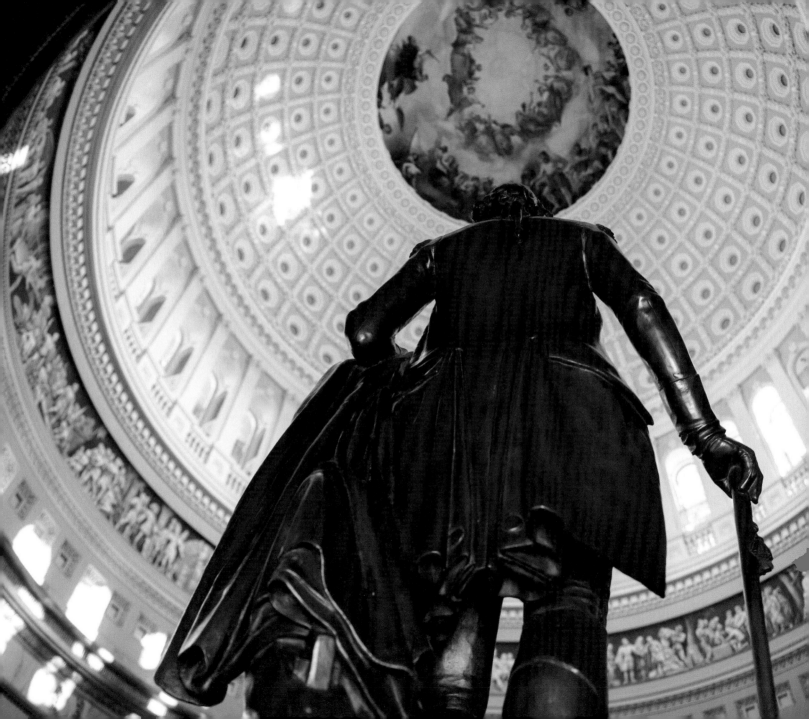

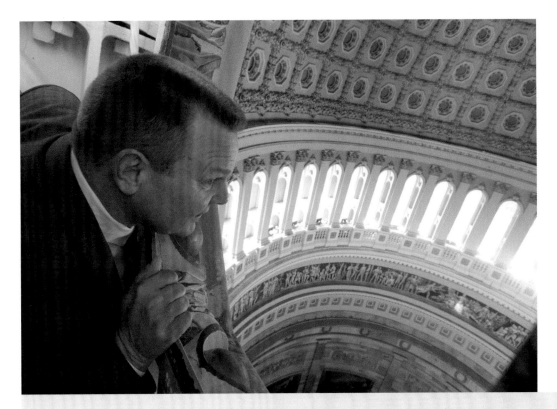

Sen. Jon Tester, D-Mont., looks down toward the floor of the Rotunda during a tour of the Capitol Dome. (Tom Williams)

The statue of George Washington stands in the Capitol Rotunda. (Bill Clark)

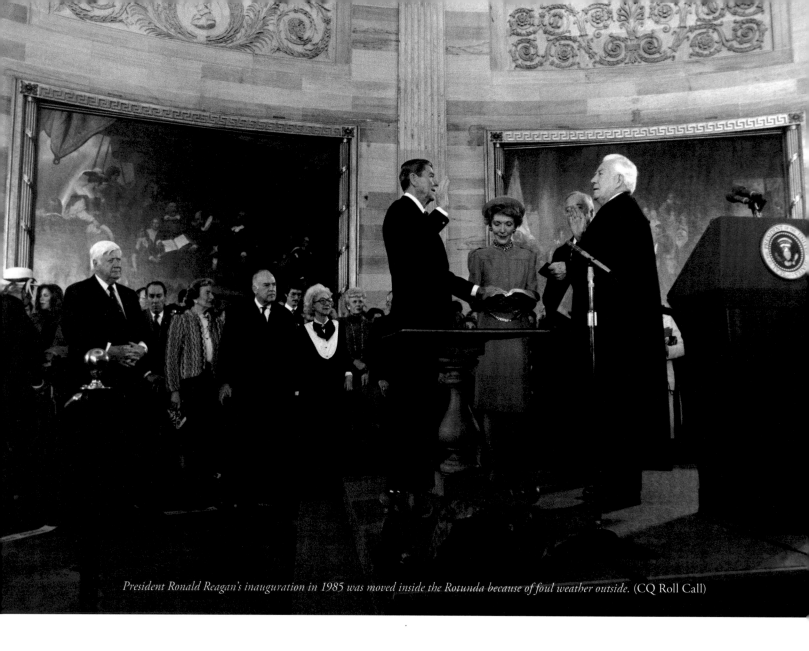

President Ronald Reagan's inauguration in 1985 was moved inside the Rotunda because of foul weather outside. (CQ Roll Call)

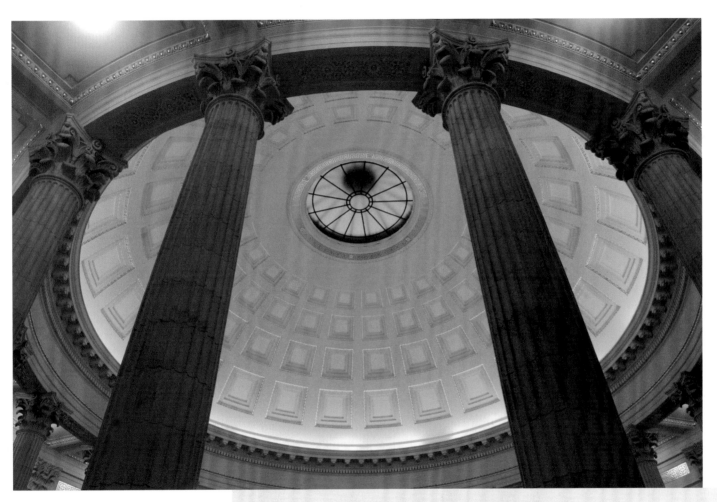

The view of the ceiling of the Rotunda in the Cannon House Office Building, the oldest of the congressional office buildings. (Scott J. Ferrell)

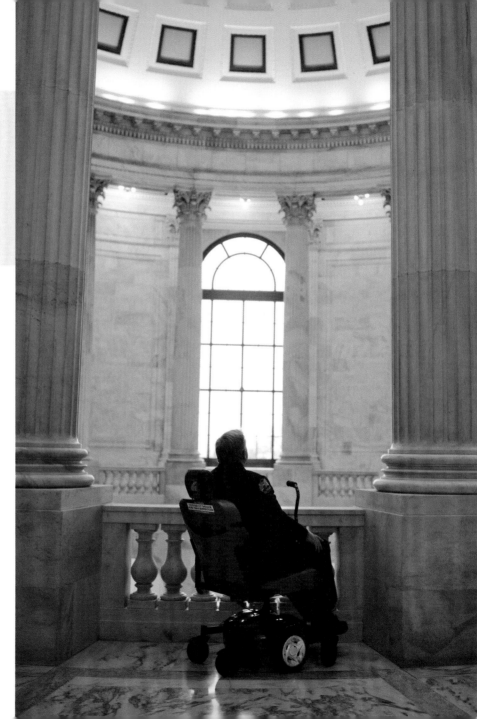

Retired Fire Department of New York firefighter Ray Pfeifer, who suffered from cancer after working at Ground Zero after the 9/11 attacks, has a quiet moment in the Cannon Rotunda. (Tom Williams)

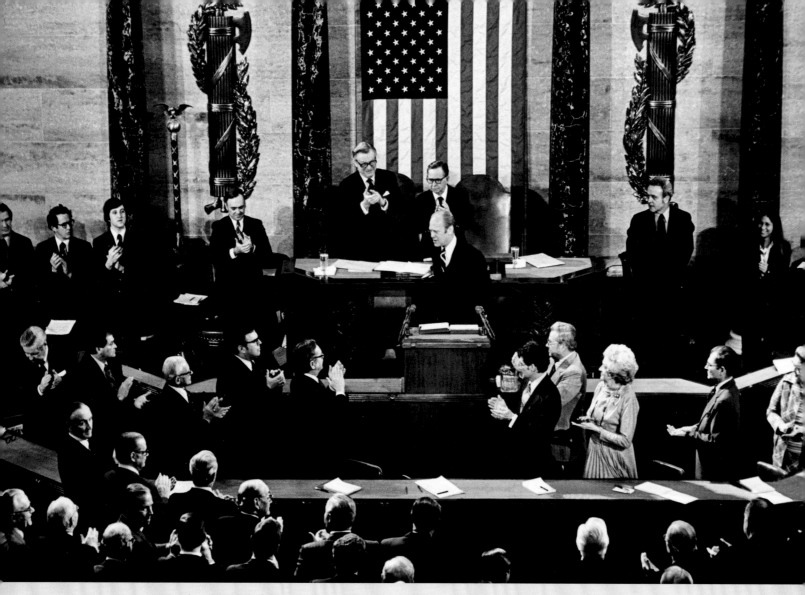

President Gerald Ford delivers a State of the Union address in the House chamber. (Dev O'Neill)

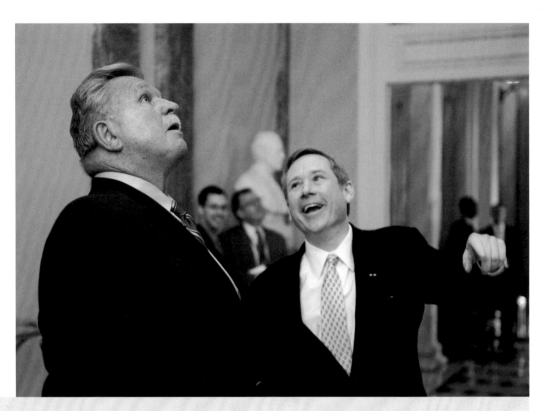

Sen. Mark Kirk, R-Ill., shows former Chicago Bears Coach Mike Ditka the massive Battle of Lake Erie *painting by William Henry Powell on the second floor of the Capitol, just steps from the Senate floor.* (Bill Clark)

Members of Congress and the media gather in the Capitol's Statuary Hall after President Barack Obama's State of the Union address. (Tom Williams)

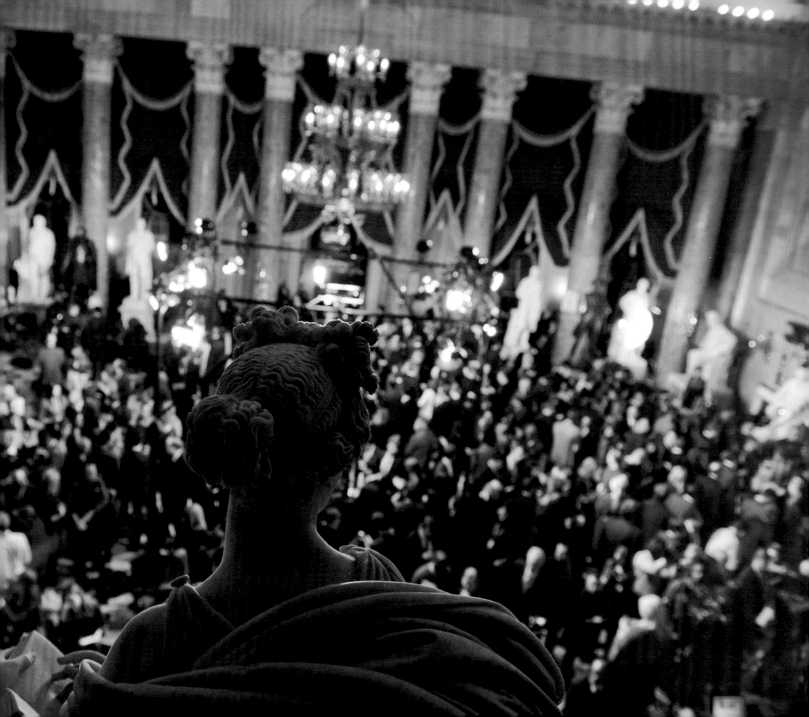

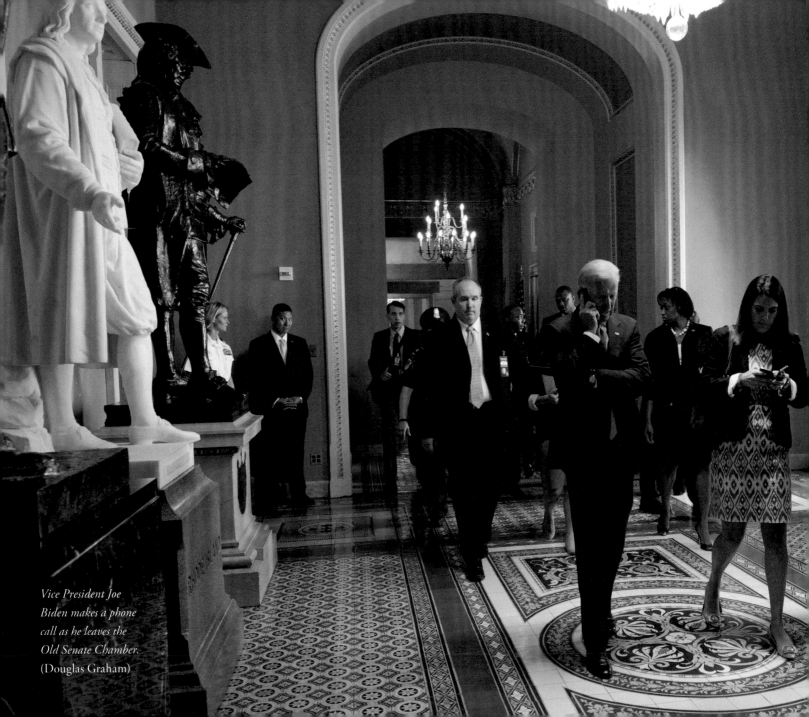

Vice President Joe Biden makes a phone call as he leaves the Old Senate Chamber. (Douglas Graham)

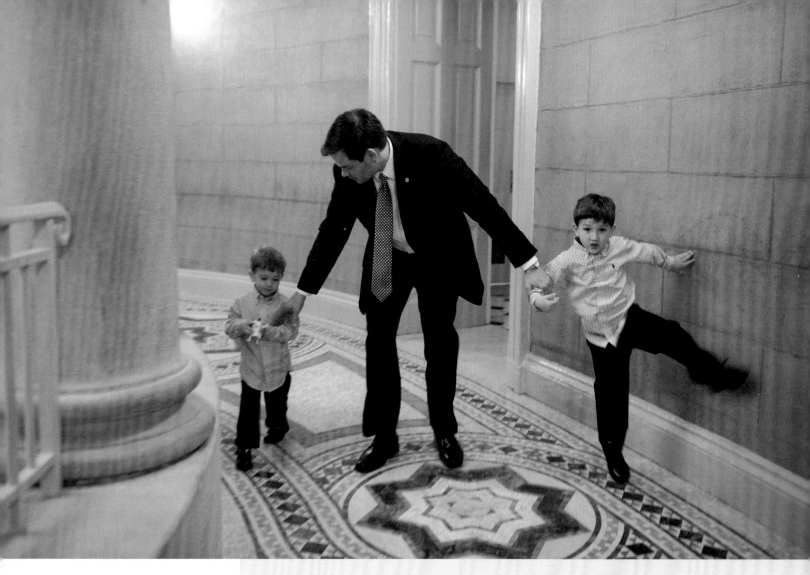

Sen. Marco Rubio, R-Fla., and his sons Anthony, right, and Dominic make their way to a mock swearing-in ceremony in the Old Senate Chamber. (Tom Williams)

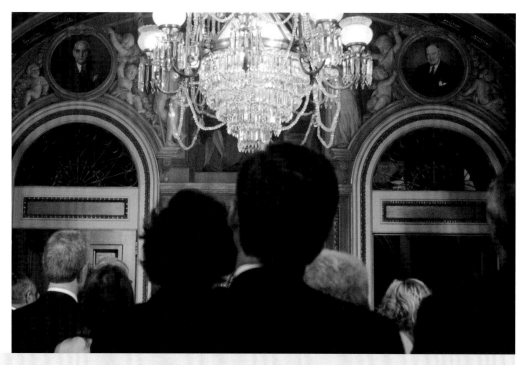

The portraits of Sen. Arthur Vandenberg, R-Mich., and Sen. Robert Wagner, D-N.Y., in the ornate Senate Reception Room. (Chris Maddaloni)

Tourists gaze up at the chandelier hanging in the Small Senate Rotunda. (Bill Clark)

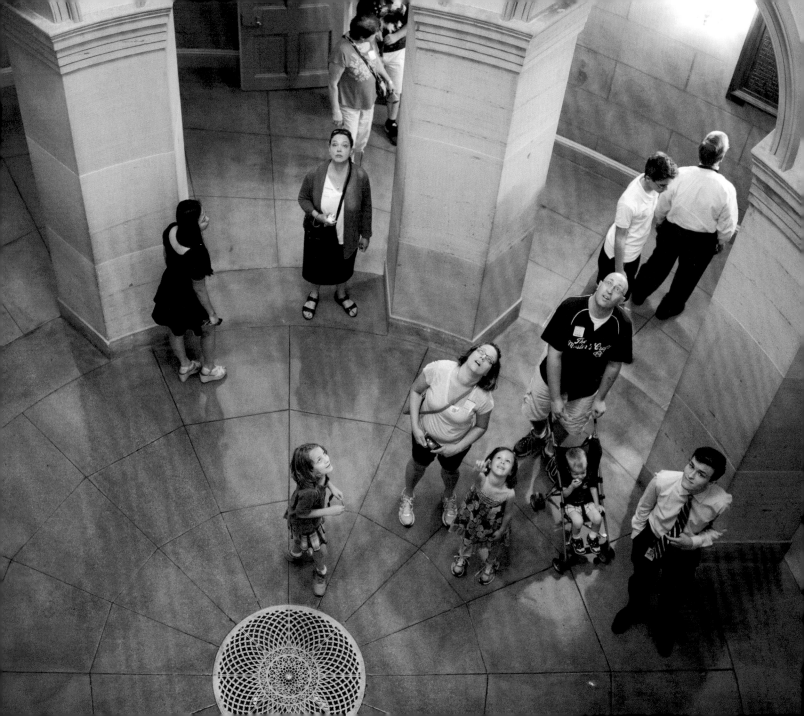

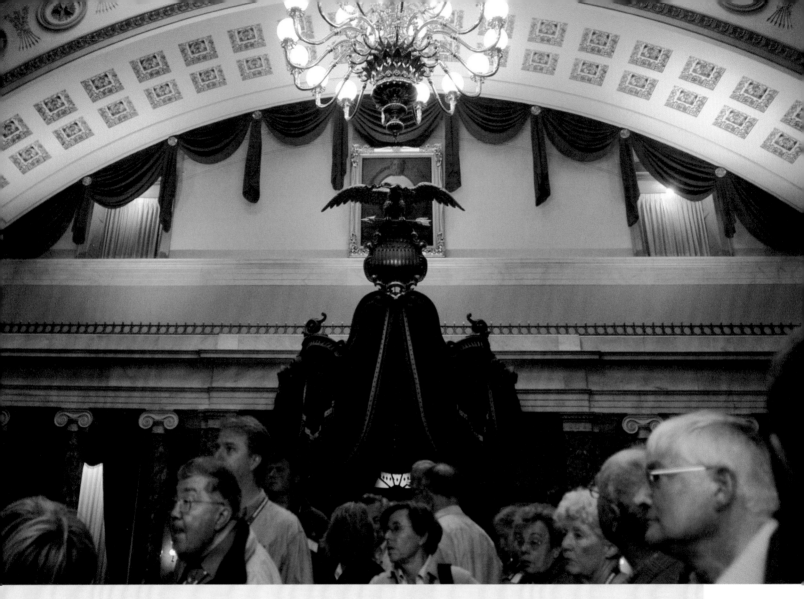

Members of the extended LaTrobe family, descendants of the original Architect of the Capitol, Benjamin LaTrobe, tour the Old Senate Chamber. (Chris Maddaloni)

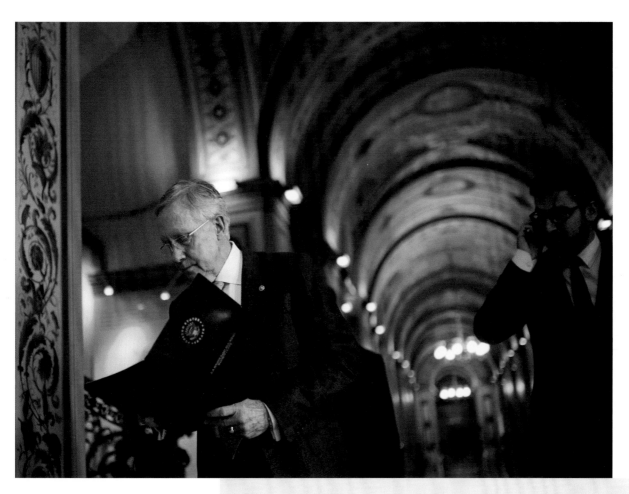

Sen. Harry Reid, D-Nev., catches up on his talking points as he walks through the Capitol's Brumidi Corridor on his way to a news conference. (Bill Clark)

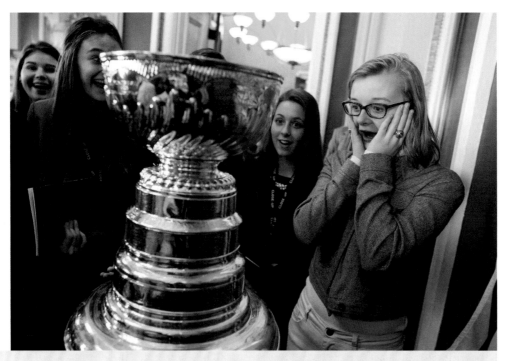

*Rose Harper, a student from Downers Grove North High School in Illinois, reacts
to seeing the Stanley Cup up close in the office of Sen. Richard J. Durbin, D-Ill.
The trophy visited the Capitol after the Chicago Blackhawks won the cup.* (Al Drago)

A woman works on her phone in the Russell Senate Office Building's rotunda. (Tom Williams)

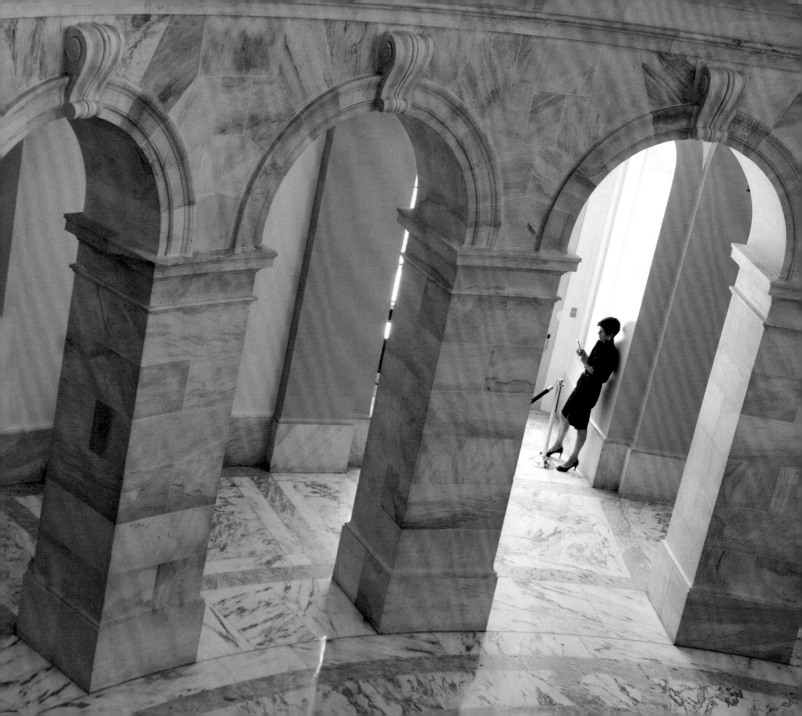

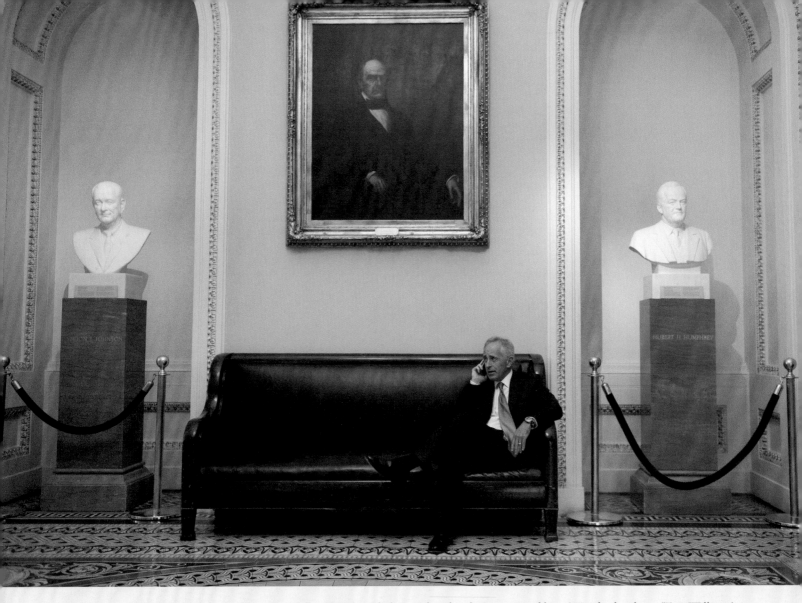

Sen. Bob Corker, R-Tenn., takes a phone call in the Ohio Clock Corridor after the Senate Republicans' Tuesday luncheon. (Tom Williams)

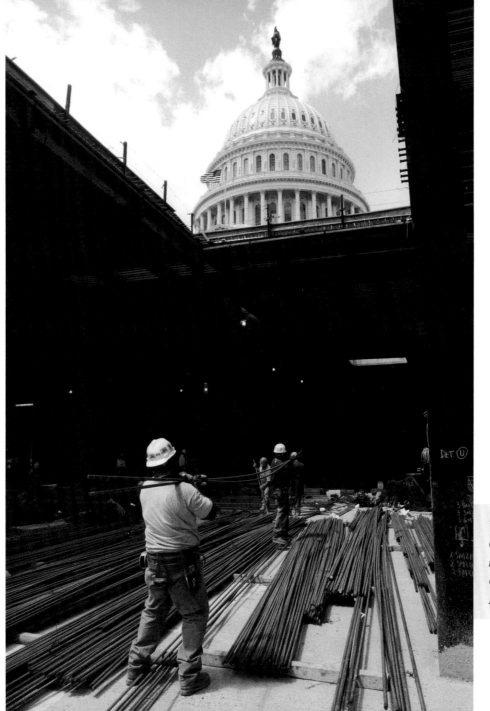

Workers constructing the Capitol Visitor Center can see the Capitol Dome through the CVC's skylight in the Great Hall. (Scott J. Ferrell)

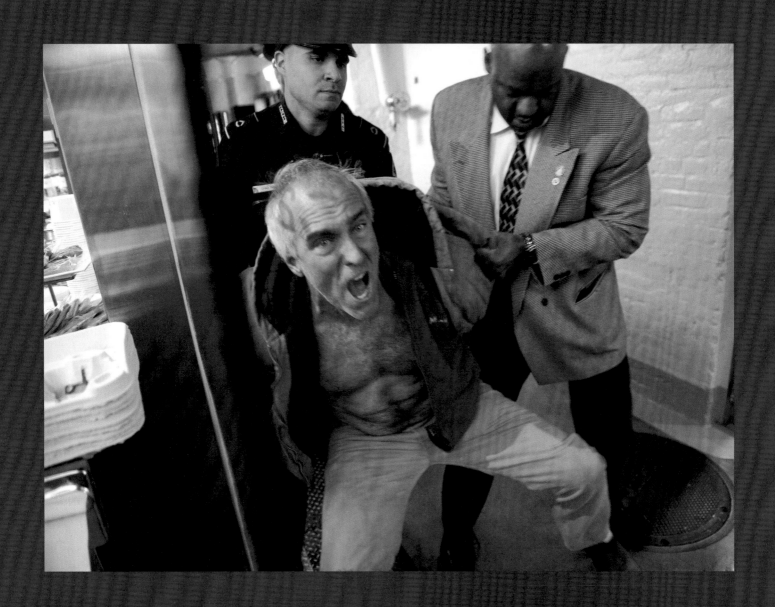

Anger

"I'm as mad as hell, and I'm not going to take this anymore."

The time was 1976. The words were from the fictional news anchor Howard Beale, who had lost his marbles after his employer the UBS network tried to fire him and then found out that his unfiltered rage was a ratings boost.

The movie *Network* has aged very well.

Anger is one of the more defining characteristics of politics, be it 1976, 1776, 2016.

Voters are angry that Congress doesn't do more to attend to their needs.

Members of Congress are angry when their legislation is voted down.

Or when they are excluded from important discussions.

Or when their integrity is questioned.

Or when the political process is used to score, well, political points.

This all happens a lot.

People get angry.

And it doesn't matter if they are presidents, senators, protesters, or representatives.

There's a lot to go around.

★ ★

Capitol Police escort Rives Grogan, an antiabortion protester, through the basement of the Capitol after he disrupted Senate proceedings from the visitor gallery. (Chris Maddaloni)

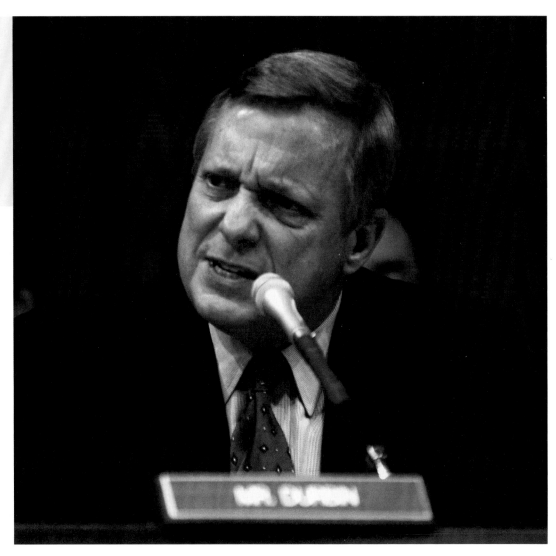

Sen. Richard J. Durbin, D-Ill., pushes back after he and his fellow Democrats were accused of opposing the nomination of William H. Pryor to be a federal judge for alleged anti-Catholic bias. Durbin is Catholic.
(Scott J. Ferrell)

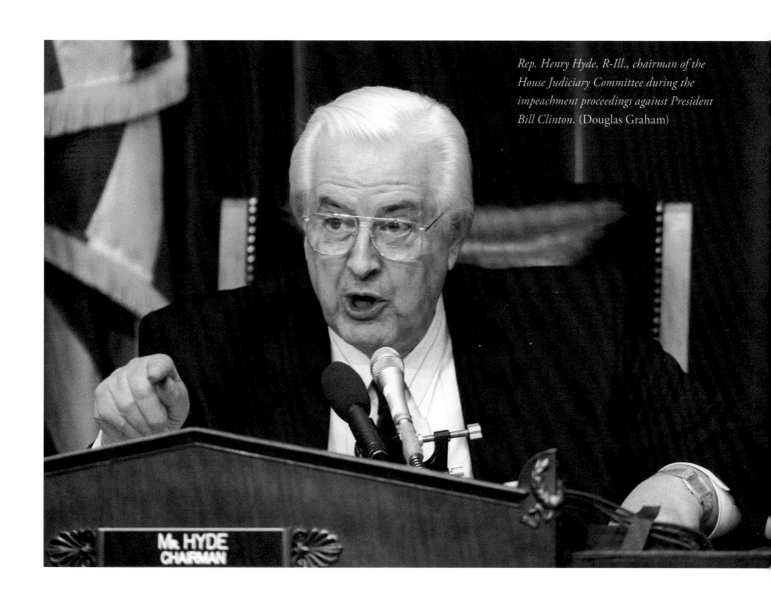

Rep. Henry Hyde, R-Ill., chairman of the House Judiciary Committee during the impeachment proceedings against President Bill Clinton. (Douglas Graham)

Mr. HYDE
CHAIRMAN

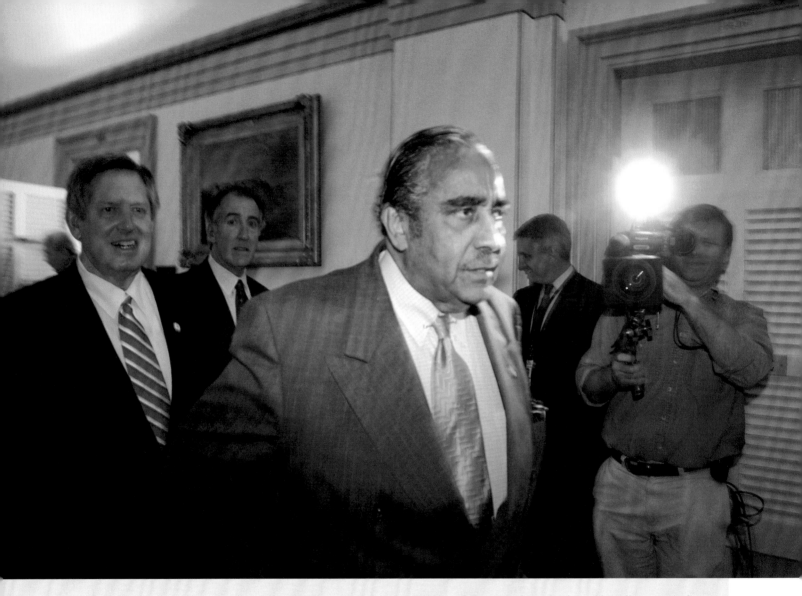

Rep. Charles Rangel, D-N.Y., on his way to lodge a complaint that he and his colleagues were being excluded from a conference committee on legislation regarding Medicare. (Douglas Graham)

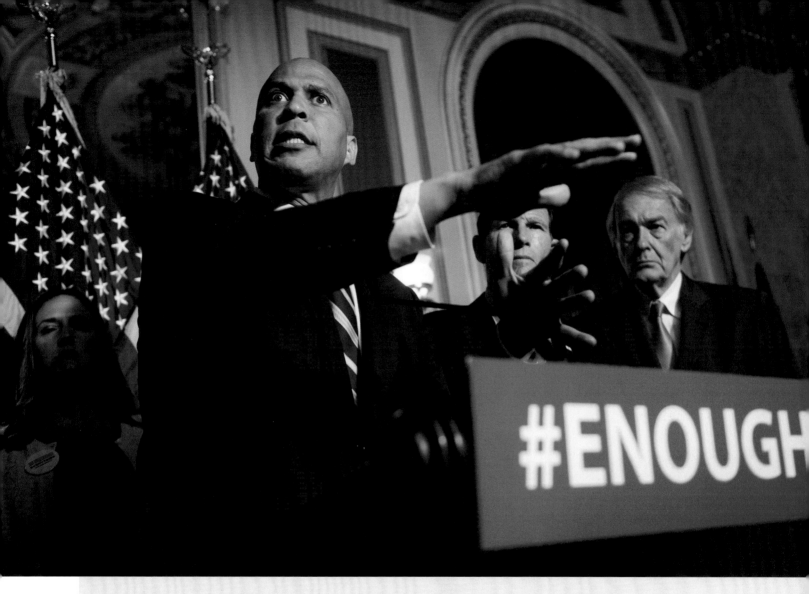

Sen. Cory Booker, D-N.J., appears with Tina Meins, whose father was killed in the 2015 mass shooting in San Bernardino, Calif., and his colleagues Richard Blumenthal, D-Conn., and Ed Markey, D-Mass., to argue for gun control. (Tom Williams)

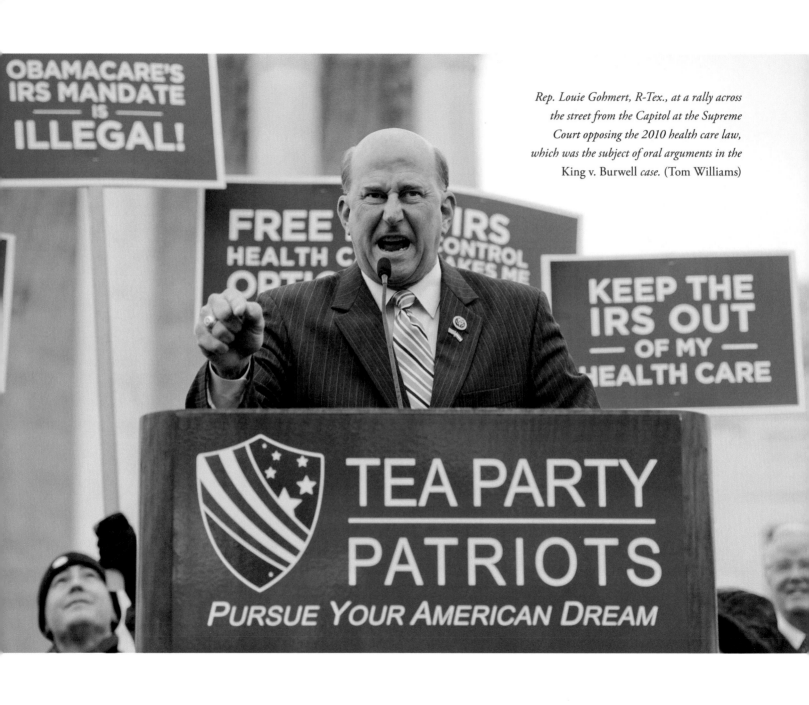

Rep. Louie Gohmert, R-Tex., at a rally across the street from the Capitol at the Supreme Court opposing the 2010 health care law, which was the subject of oral arguments in the King v. Burwell case. (Tom Williams)

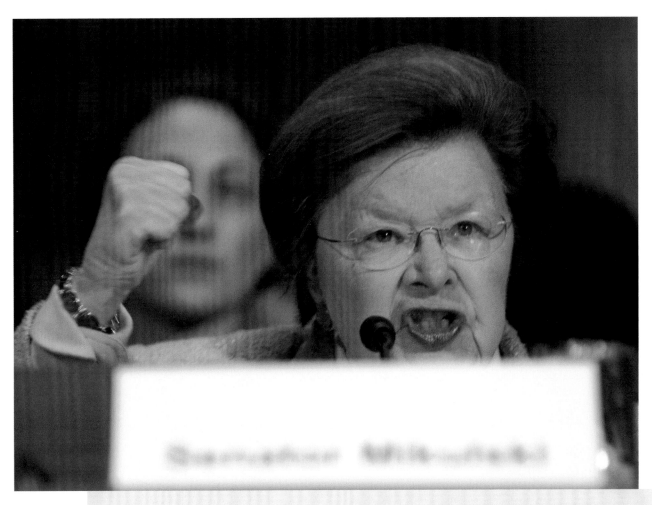

Sen. Barbara Mikulski, D-Md., appears before her colleagues on the Environment and Public Works Committee to testify on how climate change is affecting the Chesapeake Bay. (Bill Clark)

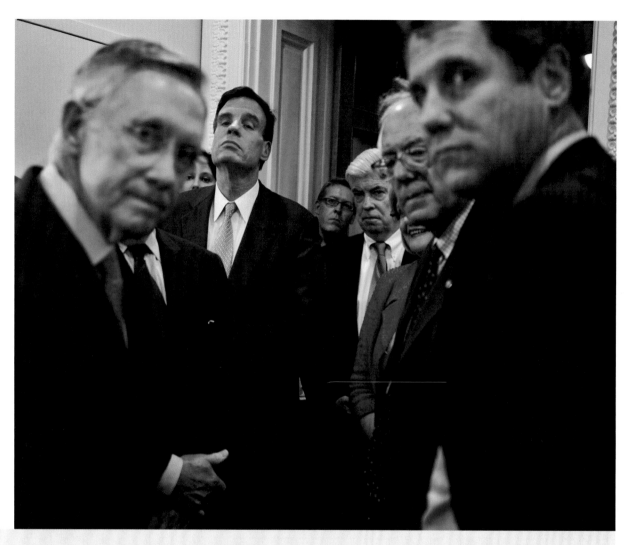

Senate Democrats are none too pleased after failing to advance legislation that would have reworked regulations governing the financial services sector. From left, Senate Majority Leader Harry Reid, D-Nev., Sen. Mark Warner, D-Va., Senate Banking Chairman Christopher J. Dodd, D-Conn., Sen. Bernie Sanders, I-Vt., and Sen. Sherrod Brown, D-Ohio. (Scott J. Ferrell)

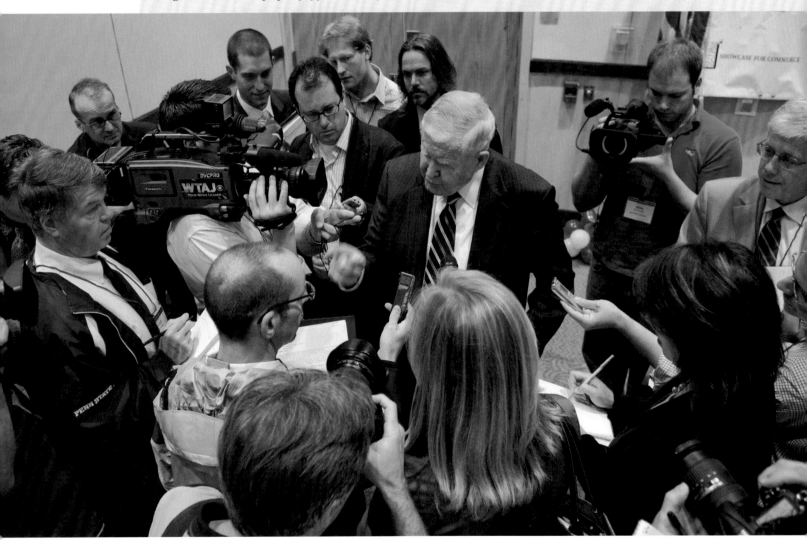

Rep. John Murtha, D-Pa., shakes his finger at Associated Press writer Dan Nephin after the reporter pressed the congressman about the propriety of federal money Murtha directed back home to his district. (Douglas Graham)

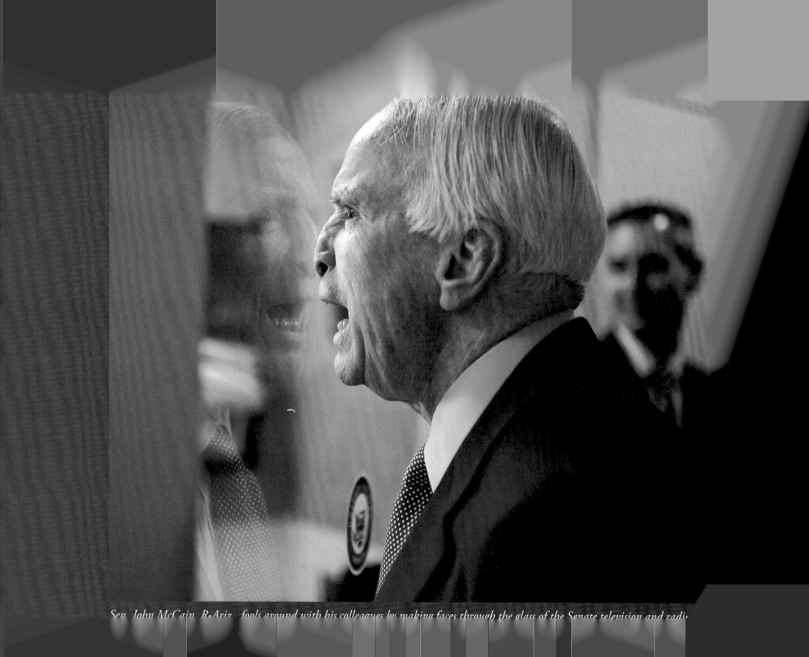

Sen. John McCain, R-Ariz., fools around with his colleagues by making faces through the glass of the Senate television and radio

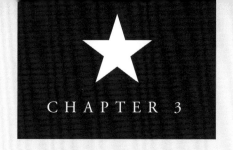

CHAPTER 3

Distraction

It's so easy to be distracted.

A colleague distracts you by making faces during an otherwise important meeting.

Someone brings a ridiculous dog into the office.

Come on! Just try the hula hoop. How hard can it be? So what if you have a suit and tie on?

And that time the Incredible Hulk came to work? Were you not supposed to put on Hulk hands and pretend to box with him? It's the Hulk! He doesn't drop by every day.

Work can wait just a little bit.

After all, there are zombies walking across the Capitol. Zombies!

And what else are you supposed to do when waiting out a fire drill. Isn't this what makeshift football games are for?

And do you really want to listen to EVERYTHING Barney Frank is saying when you can share a little secret whisper off to the side?

Nobody can do what they're supposed to do all the time, you know.

Right?

What was that?

I said . . .

★ ★

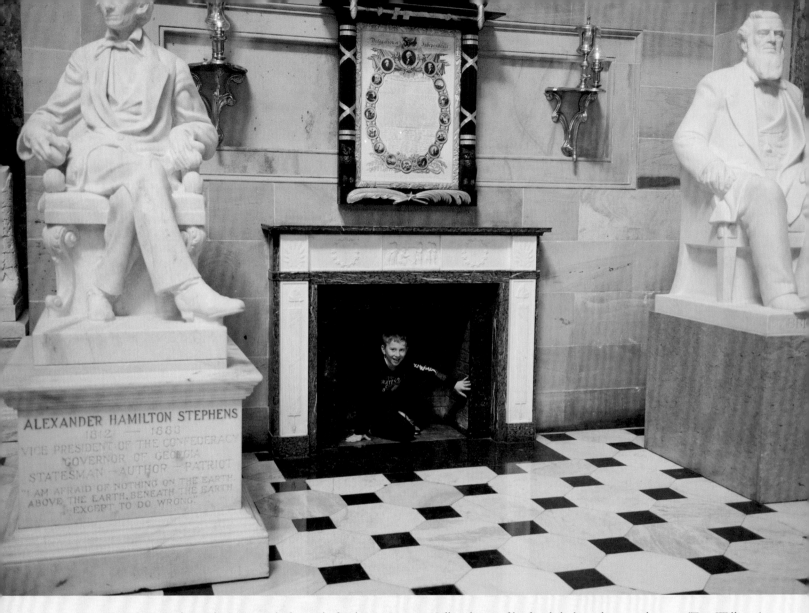

On a visit to the Capitol, Matthew Cronin checks out the fireplace in Statuary Hall as the rest of his family looks at the art and statues. (Tom Williams)

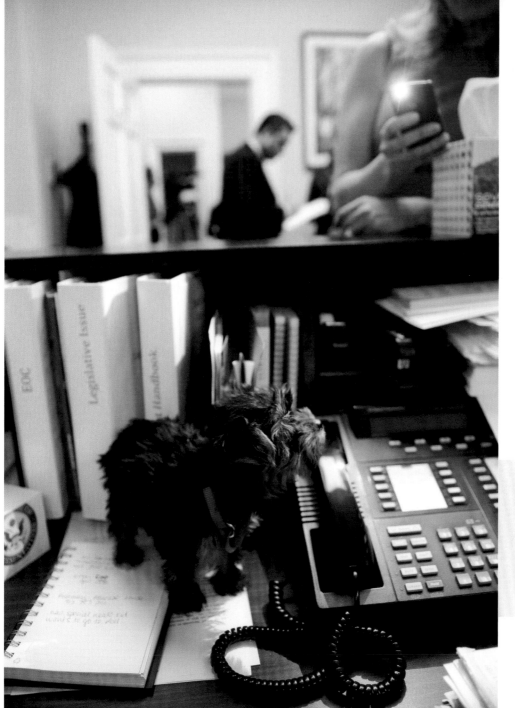

Sebastian, a Yorkshire terrier rescue dog adopted by Rep. Michael Grimm, R-N.Y., explores a desk in Grimm's office in the Cannon House Office Building.
(Tom Williams)

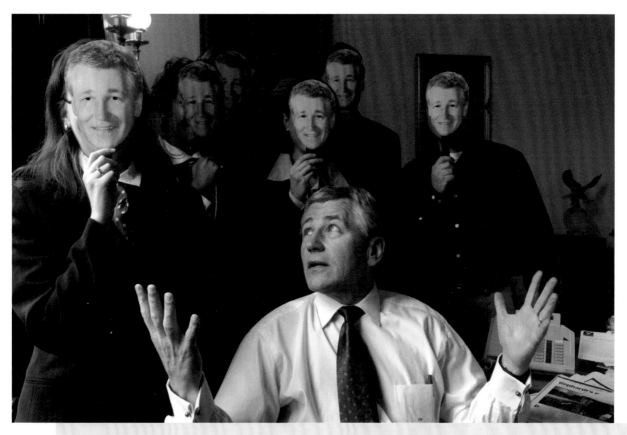

Staffers for Sen. Chuck Hagel, R-Neb., don masks of their boss on Halloween and close in on him. Hagel was notorious for dressing up on Halloween as a fellow member of Congress and heckling that person in public. (Douglas Graham)

Sen. Tom Harkin, D-Iowa, takes some time out to hula hoop on top of a giant Chutes and Ladders game board outside the Capitol. The National Women's Law Center and Moms Rising used the props to call attention to education issues. (Bill Clark)

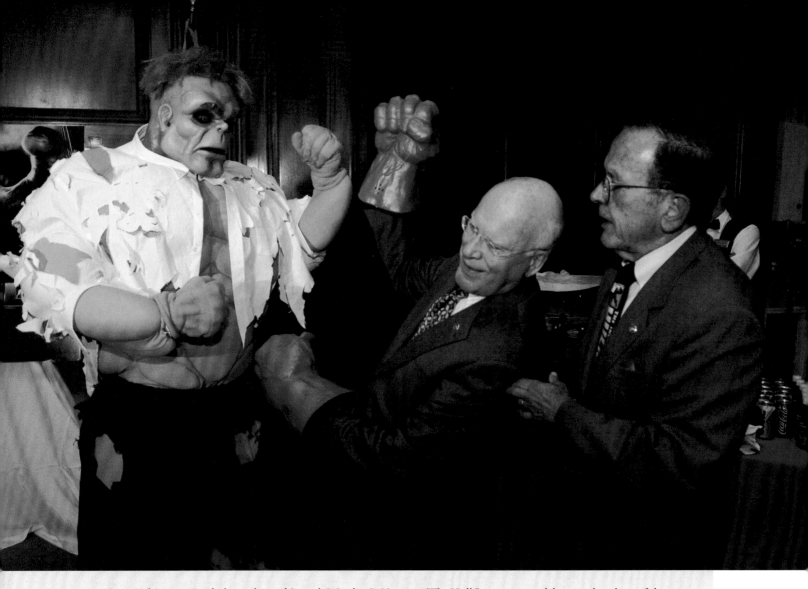

Sens. Ted Stevens, R-Alaska, right, and Patrick J. Leahy, D-Vt., meet "The Hulk" at an event celebrating the release of the movie of the same name. Stevens was known for wearing an Incredible Hulk tie during tough legislative battles. (Scott J. Ferrell)

Rep. Mike McIntyre, D-N.C., and Avi Parida of the U.S. Tennis Association play on a makeshift tennis court in the Rayburn House Office Building. (Tom Williams)

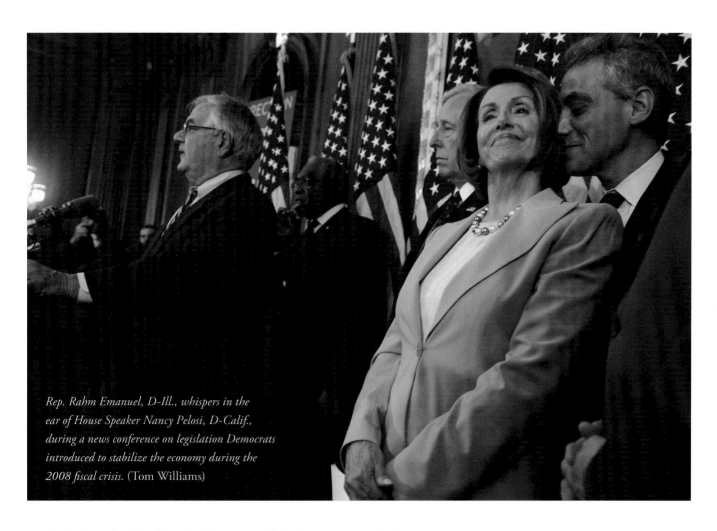

Rep. Rahm Emanuel, D-Ill., whispers in the ear of House Speaker Nancy Pelosi, D-Calif., during a news conference on legislation Democrats introduced to stabilize the economy during the 2008 fiscal crisis. (Tom Williams)

Staffers from the office of Sen. Mark Pryor, D-Ark., kill time in Stanton Park waiting for a fire drill in the Senate office buildings to be over. (Tom Williams)

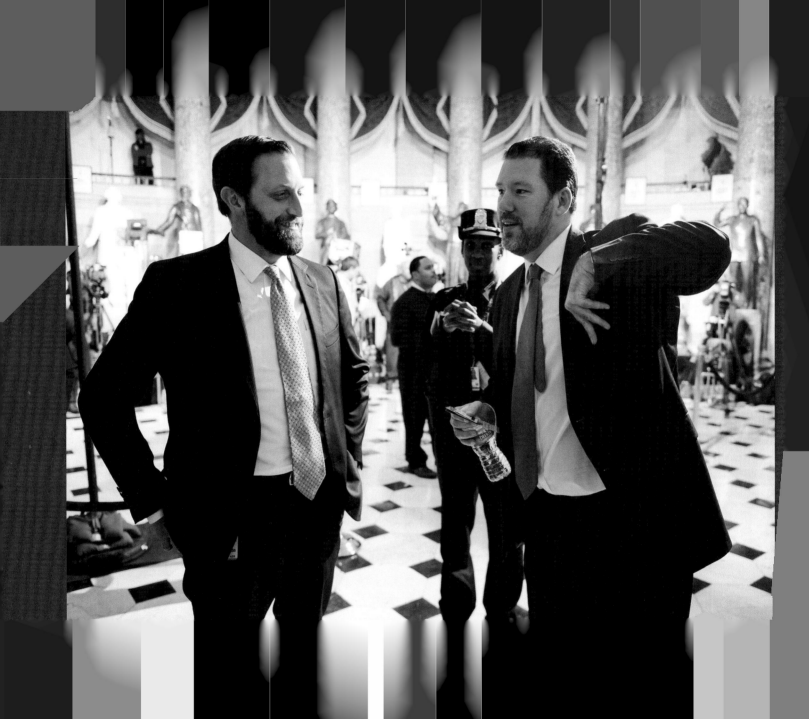

CHAPTER 4

Vigilance

To keep vigil.

It's a state of awareness. Of being on guard. Being alert.

The word vigil derives from the Latin for being awake.

One keeps vigil before a situation that might get tense, like the impeachment of a president.

One keeps vigil after a close call.

Like on the night of September 11, 2001, when no one knew if the Capitol might have been a target of airplanes looking to fly into buildings, or whether it was still a target.

It also pays to be vigilant for less dire things, too. Like making sure giant metal sculptures are structurally intact.

Or that clocks dating from the nineteenth century remain in good working order.

Or that the people wandering around the Capitol are who they say they are.

One keeps vigil when the dead lie in state, such as when a riderless horse accompanies the deceased.

It's about being careful.

It's about being mindful and watchful.

★ ★

Even senior staffers get ID'd. Doug Heye, a top aide to then–House Majority Leader Eric Cantor, R-Va., is asked for his staff identification in Statuary Hall before President Barack Obama's 2014 State of the Union address. Fellow staffer Rory Cooper is amused, because Heye didn't have it on him and had to return to his office in order to move about the Capitol. (Tom Williams)

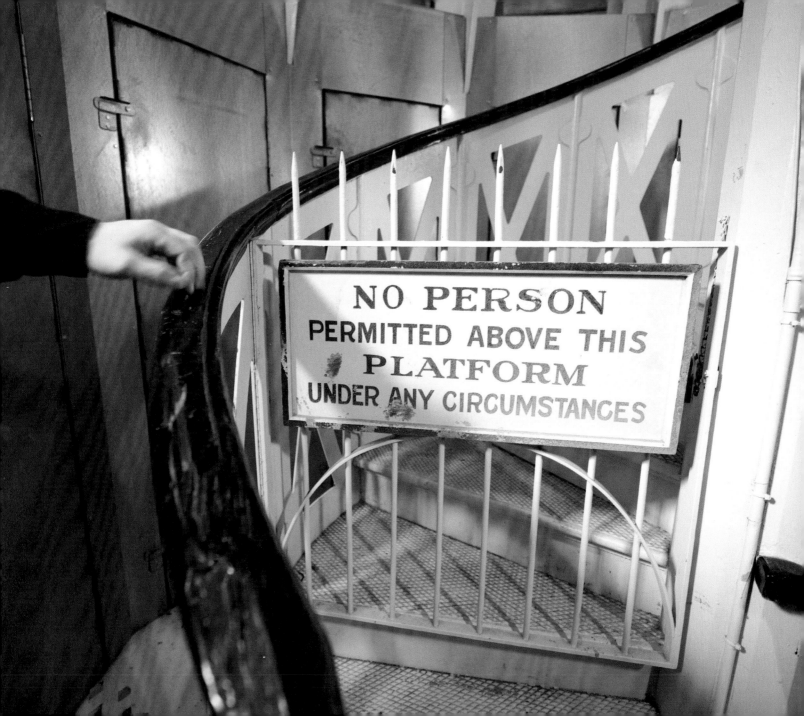

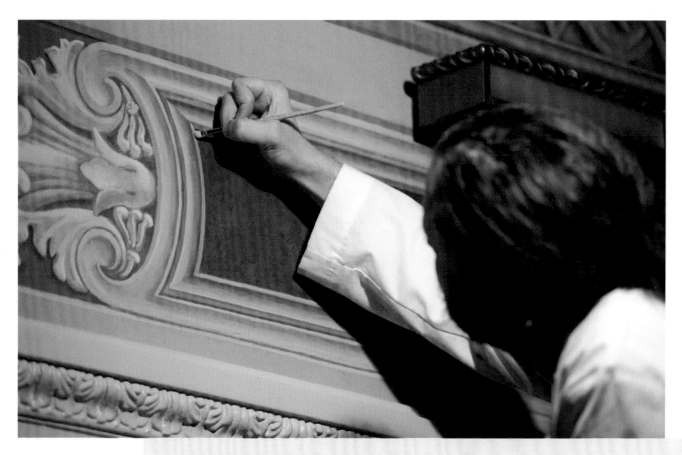

An artist with the Architect of the Capitol helps restore a portion of the Brumidi Corridors, named after the artist Constantino Brumidi, in the Capitol Reception Area. (Douglas Graham)

The Architect of the Capitol bars entrance to the stairway that leads to the very top of the Capitol Dome. The sign begs the question, though: Why have a stairway that no one is allowed to be on? (Douglas Graham)

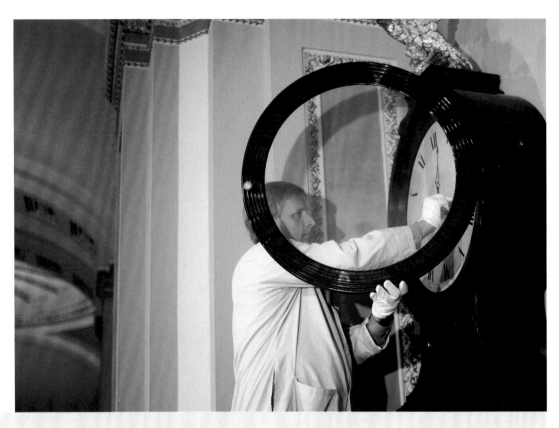

Senate museum specialist Richard Doerner moves the arms of the Ohio Clock to the correct time before winding the historic timepiece in the Capitol on October 17, 2013. The clock had been stuck at 12:14 during a government shutdown, because no staff had been available to wind it. (Bill Clark)

The clouds of Alexander Calder's Mountains and Clouds *sculpture in the Hart Senate Office Building's nine-story atrium undergo structural analysis by the Architect of the Capitol. (Bill Clark)*

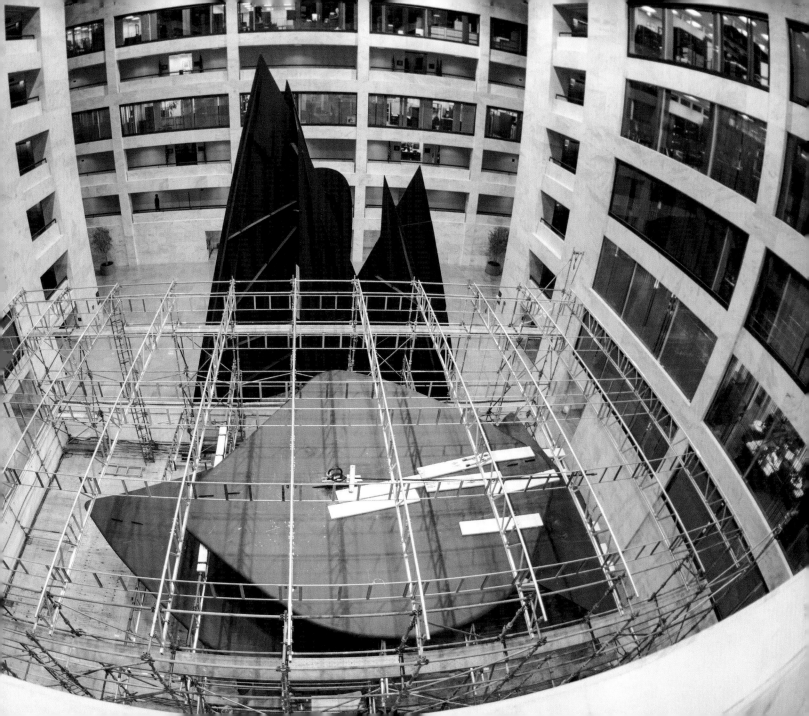

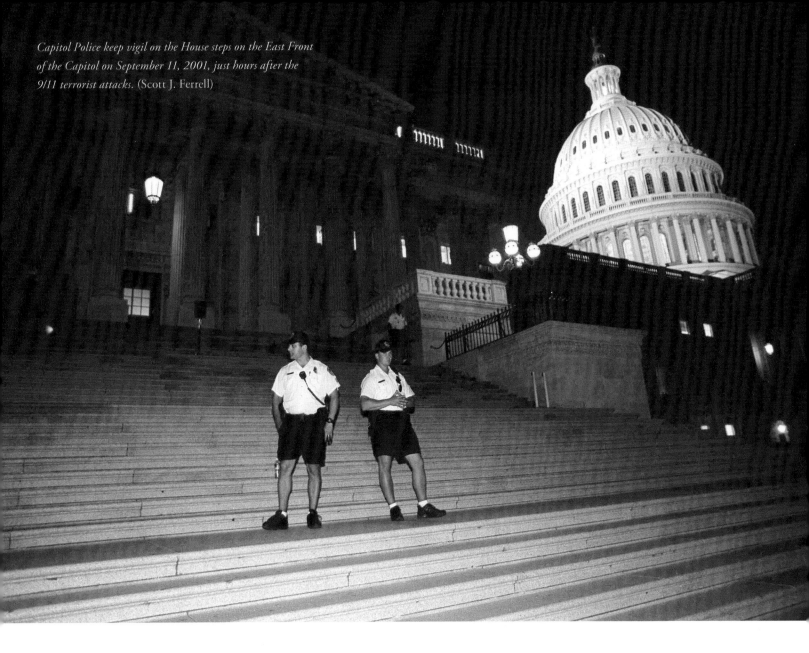

Capitol Police keep vigil on the House steps on the East Front of the Capitol on September 11, 2001, just hours after the 9/11 terrorist attacks. (Scott J. Ferrell)

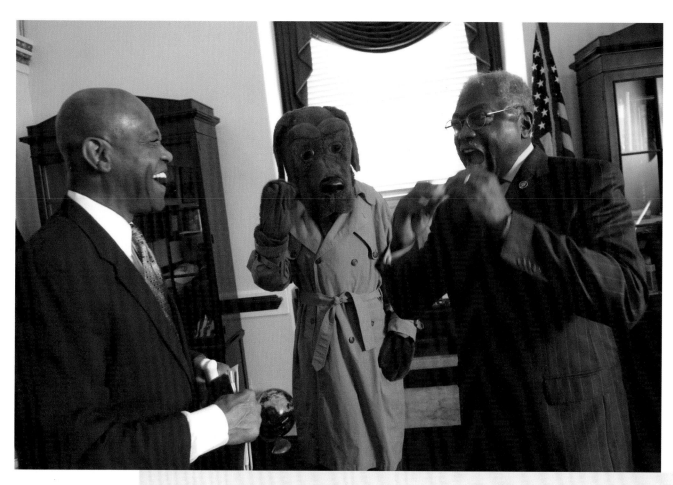

Rep. James Clyburn, D-S.C., bites into a toy bone, which was a gift from McGruff the Crime Dog and Alfonso Lenhardt, president and CEO of the National Crime Prevention Council, during a visit to Capitol Hill. McGruff's trademark line is "Take a bite out of crime," which Clyburn is making a nod to. (Tom Williams)

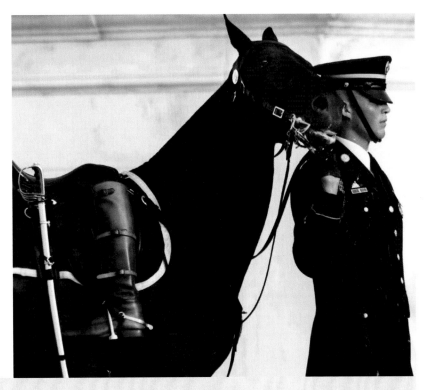

A member of the Old Guard leads the riderless horse, with President Ronald Reagan's riding boots turned backwards in the stirrups, as Reagan's body arrives at the Capitol to lie in state. The riderless horse is a longstanding tradition for funeral processions. (Scott J. Ferrell)

Terrance W. Gainer, the Senate sergeant at arms, looks down on the Cannon House Office Building rotunda as people sign well wishes for Rep. Gabrielle Giffords, D-Ariz., after she was shot and injured by a would-be assassin. The sergeant at arms is the chamber's top law enforcement official. Gainer was also formerly the chief of Capitol Police. (Bill Clark)

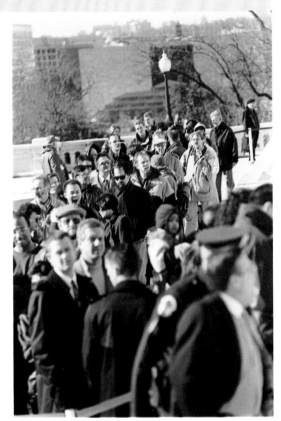

Crowds wait in line for a chance to watch the impeachment trial of President Bill Clinton. (Rebecca Roth)

Capitol Police stand guard during the Senate impeachment trial of President Bill Clinton. (Rebecca Roth)

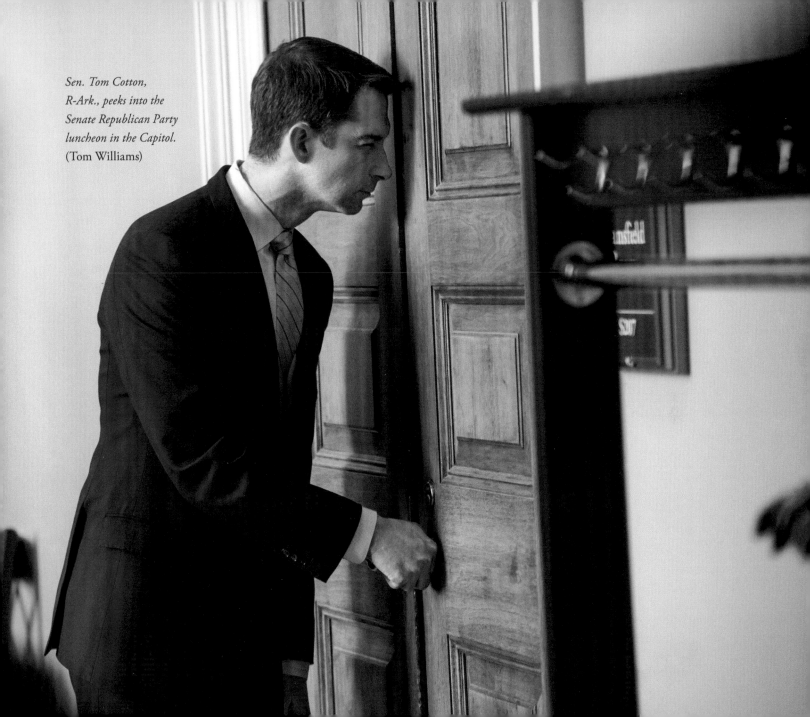

Sen. Tom Cotton, R-Ark., peeks into the Senate Republican Party luncheon in the Capitol. (Tom Williams)

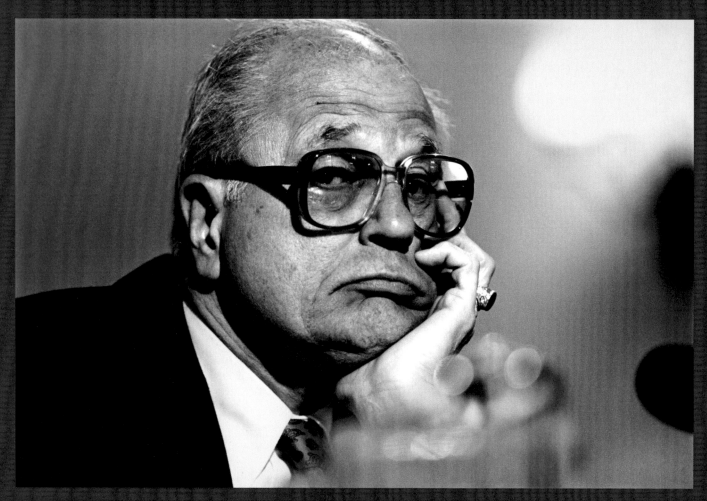

Rep. John Dingell, D-Mich., chairman of the House Energy and Commerce Committee, waits for his panel to vote on a budget request.
(Laura Patterson)

Boredom

Bored. Bored to pieces. Bored to tears. Bored to death. Bored of being bored.

There is an endless supply of colorful ways to describe the frame of mind of the bored.

People can tell when someone is bored.

The glazed eyes.

The pained look that says you aren't paying attention.

The effort to look like you're working when you're not.

Boredom.

It sometimes gets a bad rap—"Life is only boring to the boring" might be something your mother said to you once.

But it's not always a bad thing.

You could be gently spacing out while waiting for the big event to start.

You could be coping with that most unfortunate of acquaintances, the bore.

You could be in the middle of other people's uncomfortable conversation.

It can be a comfortable escape.

And you know it when you see it, because we have all been there.

That time when you spot it on someone else's face?

That's when it's funny.

Because you know that person's bored, and you're not.

★ ★

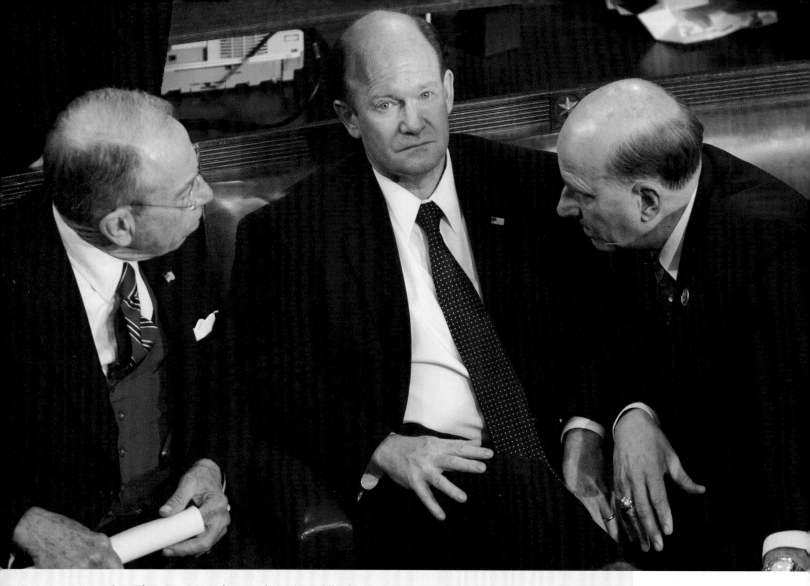

Sen. Chris Coons, D-Del., is caught in the middle of a conversation between Sen. Chuck Grassley, R-Iowa, left, and Rep. Louie Gohmert, R-Tex. (Tom Williams)

Sen. Al Franken, D-Minn., waits for a staffer to bring him the key to his Capitol hideaway office. (Tom Williams)

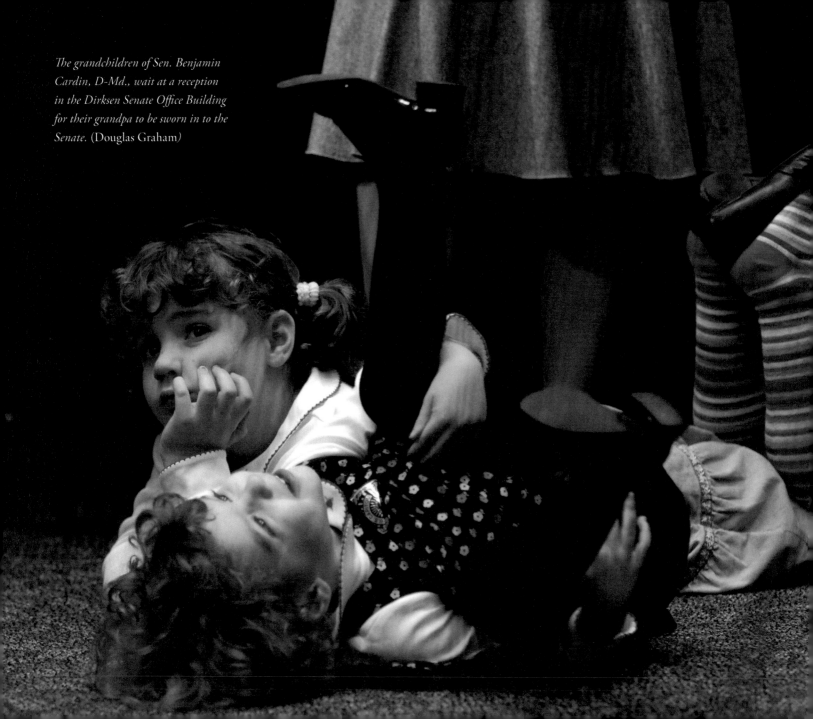

The grandchildren of Sen. Benjamin Cardin, D-Md., wait at a reception in the Dirksen Senate Office Building for their grandpa to be sworn in to the Senate. (Douglas Graham)

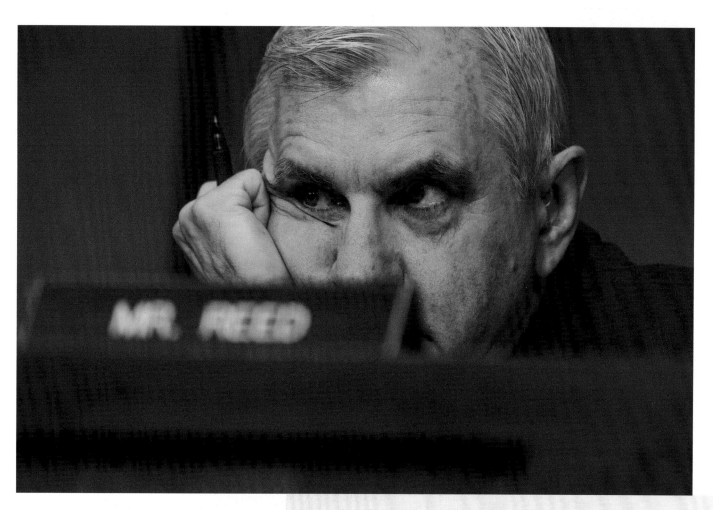

Sen. Jack Reed, D-R.I., listens to intelligence officials testify at a Senate Intelligence Committee hearing. (Tom Williams)

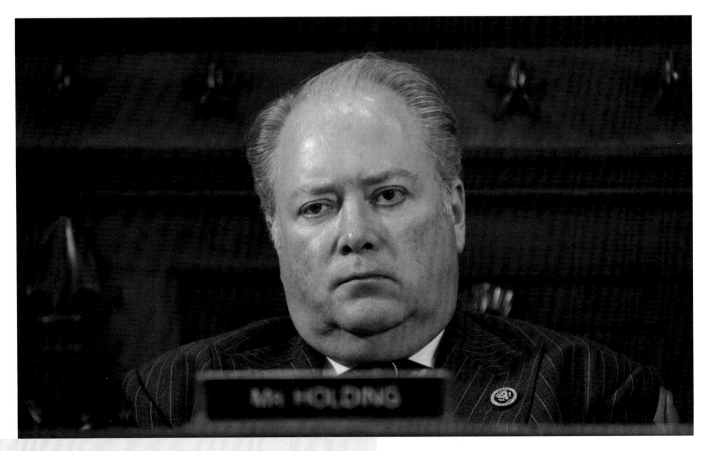

Rep. George Holding, R-N.C., listens during a Ways and Means Committee hearing on the federal budget. (Bill Clark)

Rep. Eliot Engel, D-N.Y., reads while waiting for President Barack Obama to deliver his first State of the Union address to Congress. (Bill Clark)

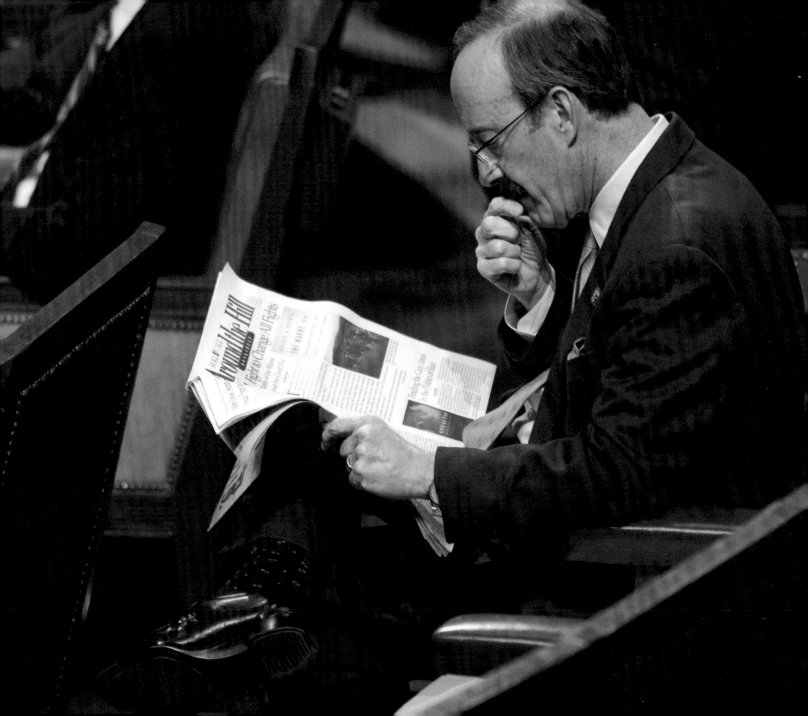

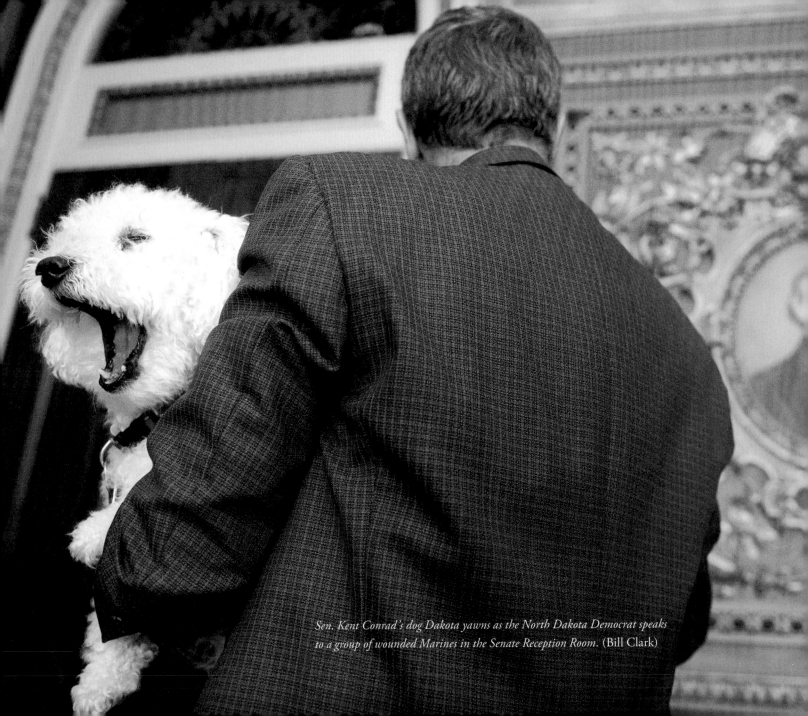

Sen. Kent Conrad's dog Dakota yawns as the North Dakota Democrat speaks to a group of wounded Marines in the Senate Reception Room. (Bill Clark)

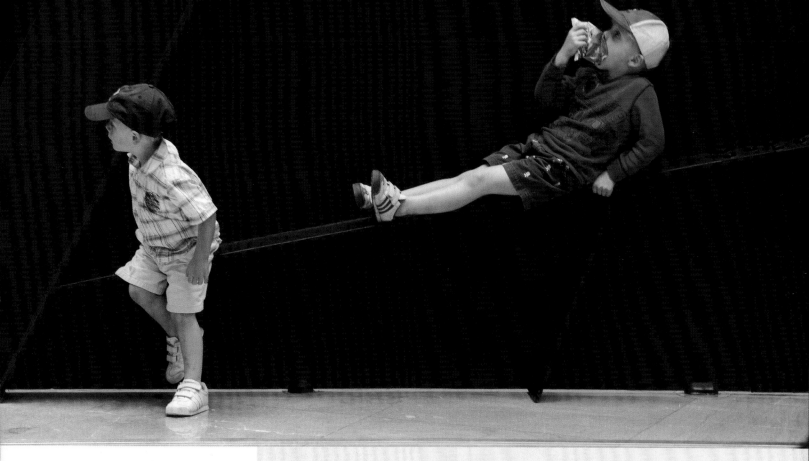

Willie and Henry Gunlock play on Alexander Calder's sculpture Mountains and Clouds *in the atrium of the Hart Senate Office Building.* (Douglas Graham)

Tourists are the lone passengers riding the Senate subway from the Russell Senate Office Building to the Capitol building during a slow recess week. (Douglas Graham)

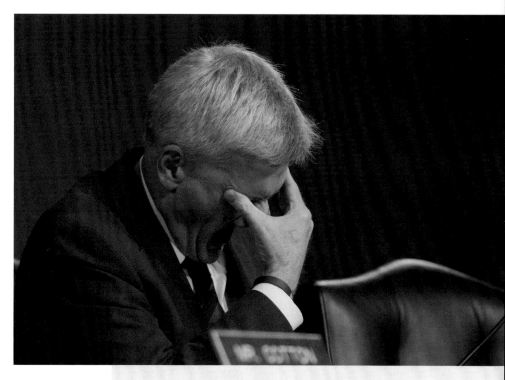

Sen. Bill Cassidy, R-La., yawns as he listens to a Joint Economic Committee hearing on the state of the Social Security Disability Insurance program. (Al Drago)

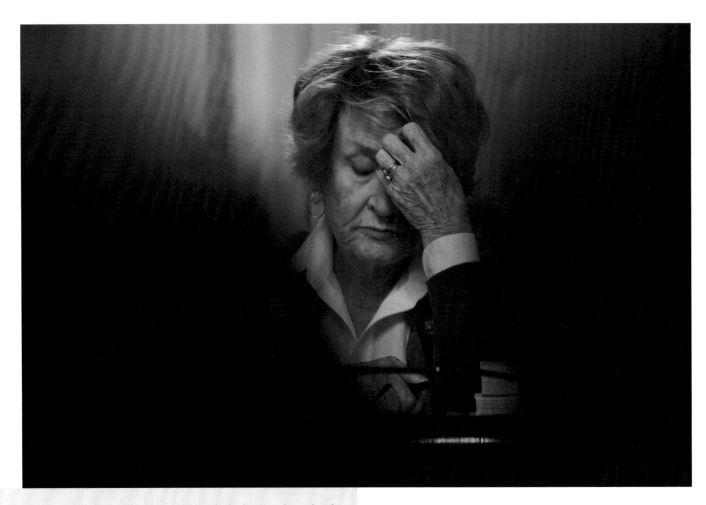

Rep. Louise Slaughter, D-N.Y., looks down in the midst of a marathon meeting of the House Rules Committee. (Al Drago)

David Letterman, basking in his post-retirement phase in the Hart Senate Office Building. (Tom Williams)

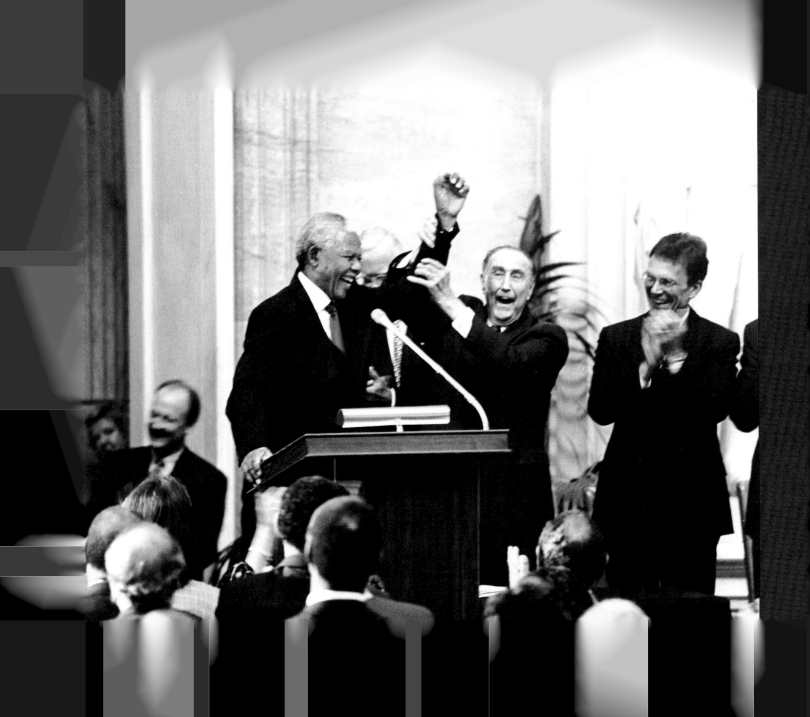

CHAPTER 6

Admiration

Who gets to be admired?

It can range from the loftiest spiritual figures, a Pope Francis here, a Dalai Lama there.

To transcendent politicians, such as dissident freedom fighters who go on to lead their countries, like Nelson Mandela.

To survivors like Elie Wiesel, who made it through the Holocaust and dedicated his life to never forgetting.

It can be someone who can throw a baseball with precision, like Max Scherzer.

Maybe it's someone who can throw a punch, like Muhammad Ali, and then teams up with a beloved actor, Michael J. Fox, to fight for a cure for Parkinson's disease.

It can be a businessman whose life becomes a reality show.

Or people who stood up for their, and everyone's, civil rights.

And sometimes those who are admired do the admiring, as when actor Bryan Cranston stops to ponder the statue of Will Rogers, or when rock guitarist Billy Gibbons pays tribute to another freedom fighter who led his country, Vaclav Havel—who loved American rock and roll and particularly Gibbons' band, ZZ Top.

The people we admire tell others what our values are, what we think is important, and who led the way for the rest of us.

★ ★

South African President Nelson Mandela receives the Congressional Gold Medal, as Sen. Strom Thurmond, R-S.C., a former fervid segregationist, congratulates him. (CQ Roll Call)

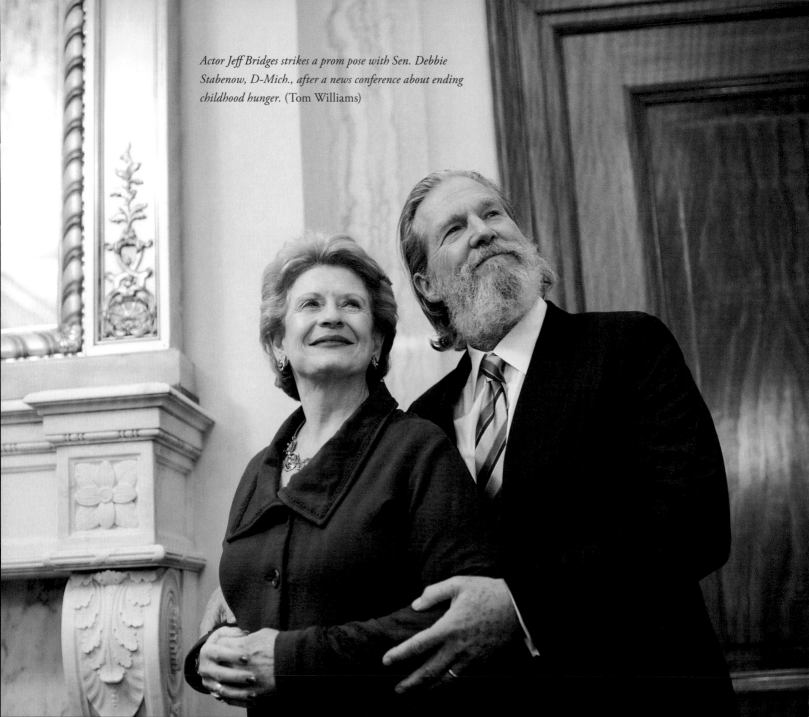

Actor Jeff Bridges strikes a prom pose with Sen. Debbie Stabenow, D-Mich., after a news conference about ending childhood hunger. (Tom Williams)

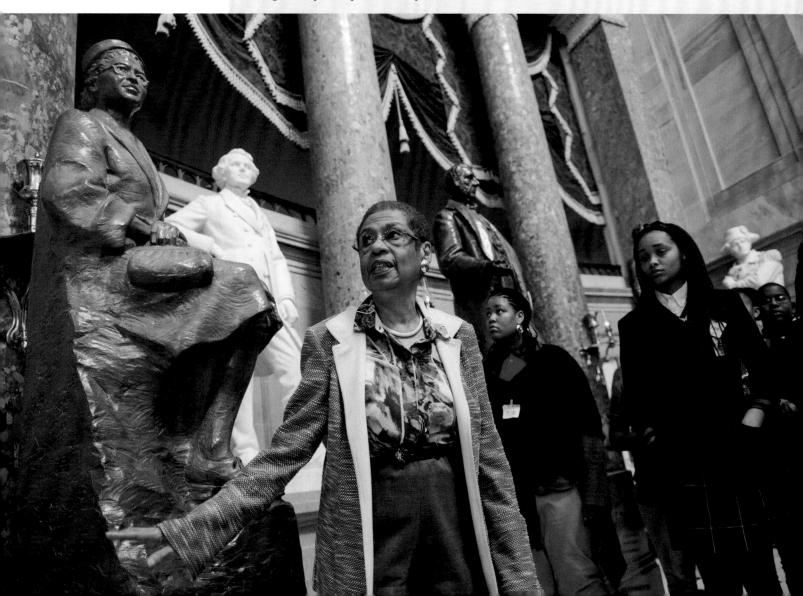

Del. Eleanor Holmes Norton, D-D.C., talks about the statue of civil rights icon Rosa Parks during a tour of the Capitol's Statuary Hall. (Tom Williams)

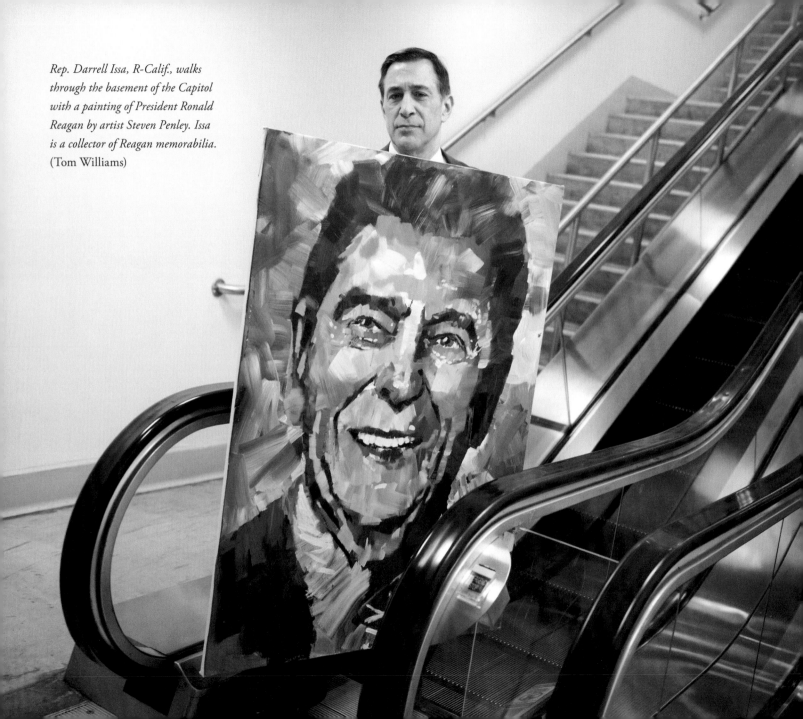

Rep. Darrell Issa, R-Calif., walks through the basement of the Capitol with a painting of President Ronald Reagan by artist Steven Penley. Issa is a collector of Reagan memorabilia. (Tom Williams)

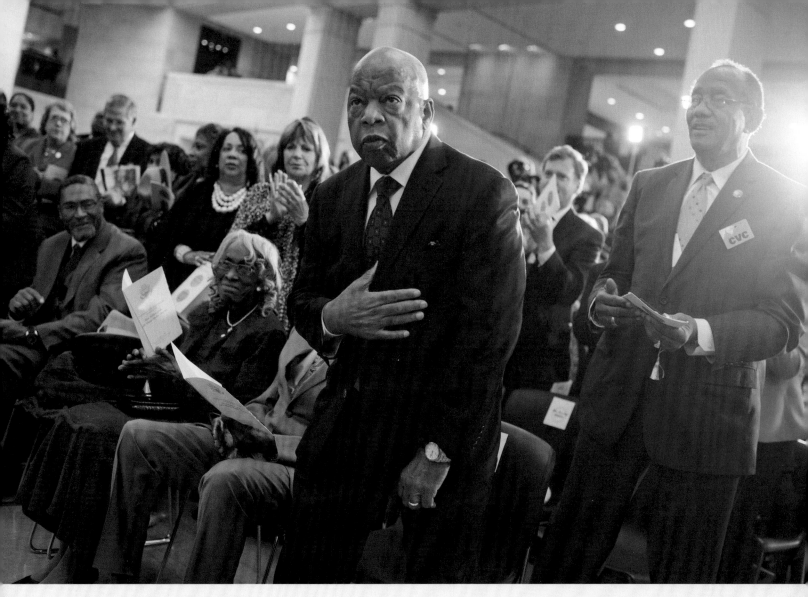

Rep. John Lewis, D-Ga., is recognized during the Congressional Gold Medal ceremony for the foot soldiers of the 1965 voting rights marches. Lewis and many others were beaten during the march from Selma to Montgomery, Alabama, to protest the denial of their right to vote. (Tom Williams)

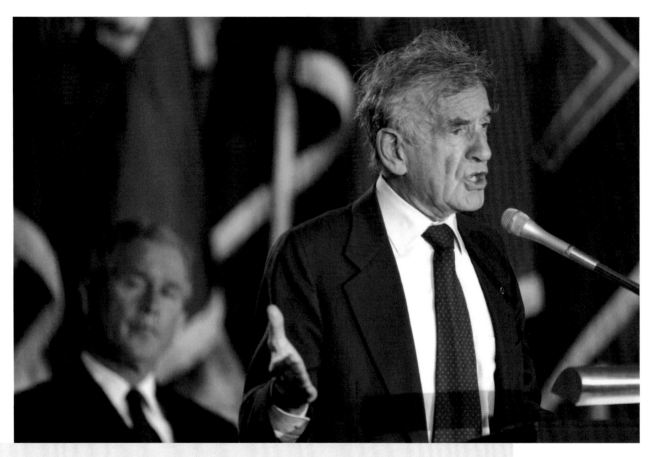

Elie Wiesel, the Holocaust survivor and Nobel Peace Prize laureate, speaks during the Holocaust Day of Remembrance in the Capitol Rotunda as President George W. Bush listens. (Douglas Graham)

Rep. Vance McAllister, R-La., walks with his guest for the State of the Union, Duck Dynasty's Willie Robertson, in the tunnel from the House to the Cannon House Office Building. (Tom Williams)

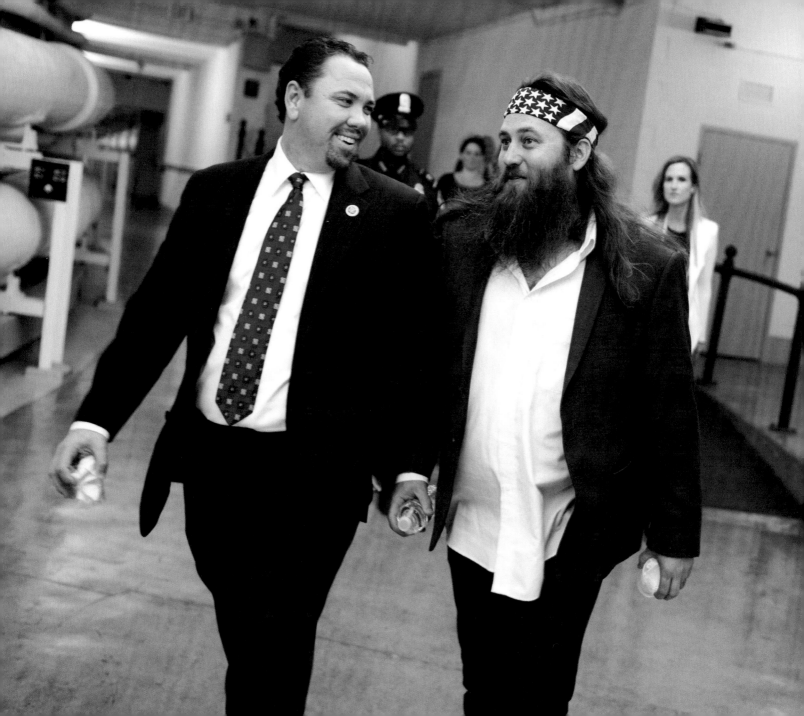

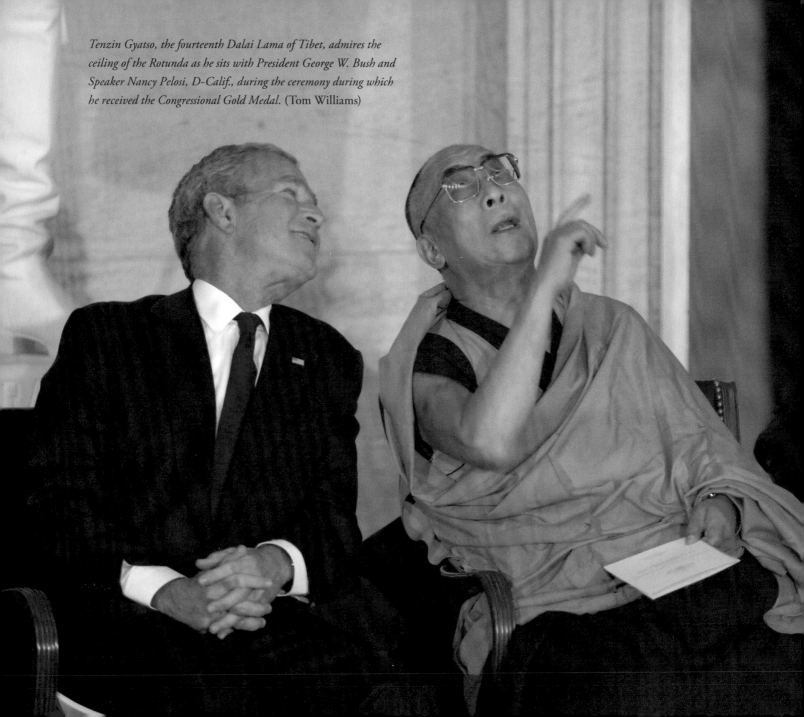

Tenzin Gyatso, the fourteenth Dalai Lama of Tibet, admires the ceiling of the Rotunda as he sits with President George W. Bush and Speaker Nancy Pelosi, D-Calif., during the ceremony during which he received the Congressional Gold Medal. (Tom Williams)

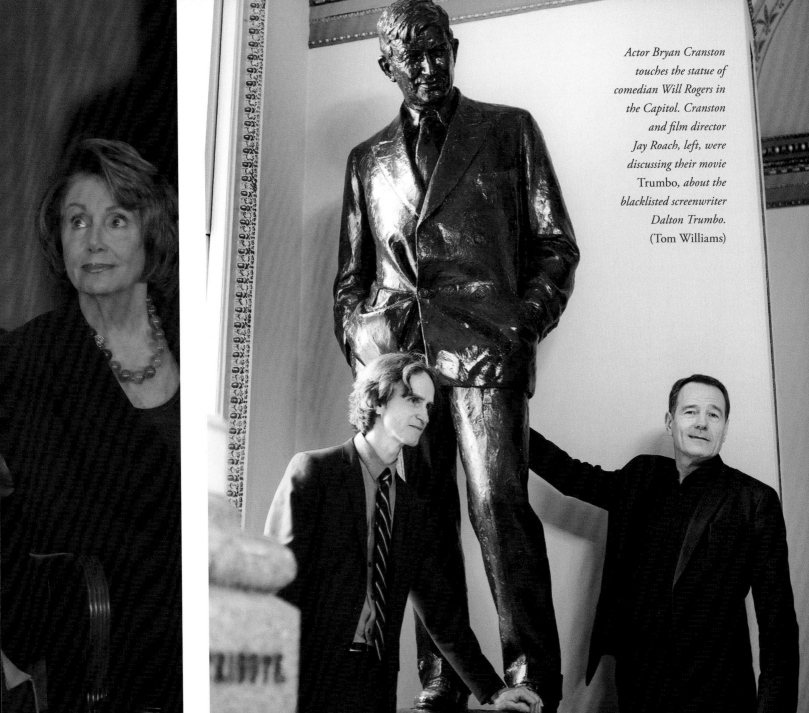

Actor Bryan Cranston touches the statue of comedian Will Rogers in the Capitol. Cranston and film director Jay Roach, left, were discussing their movie Trumbo, *about the blacklisted screenwriter Dalton Trumbo.* (Tom Williams)

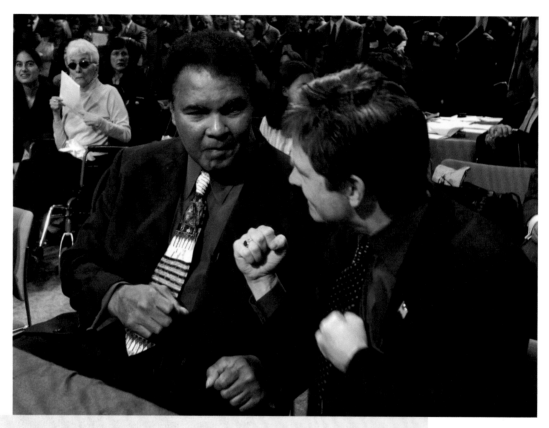

Former boxing champion Muhammad Ali and actor Michael J. Fox ham it up before the start of a hearing on Parkinson's disease. Both men suffer from the disease and Fox founded the Michael J. Fox Foundation for Parkinson's Disease. (Douglas Graham)

Washington Nationals pitcher Max Scherzer and his wife, Erica May-Scherzer, talk to Sen. John McCain, R-Ariz., as Sen. Jeff Flake, R-Ariz., looks on. Scherzer was drafted by the Arizona Diamondbacks baseball club. (Tom Williams)

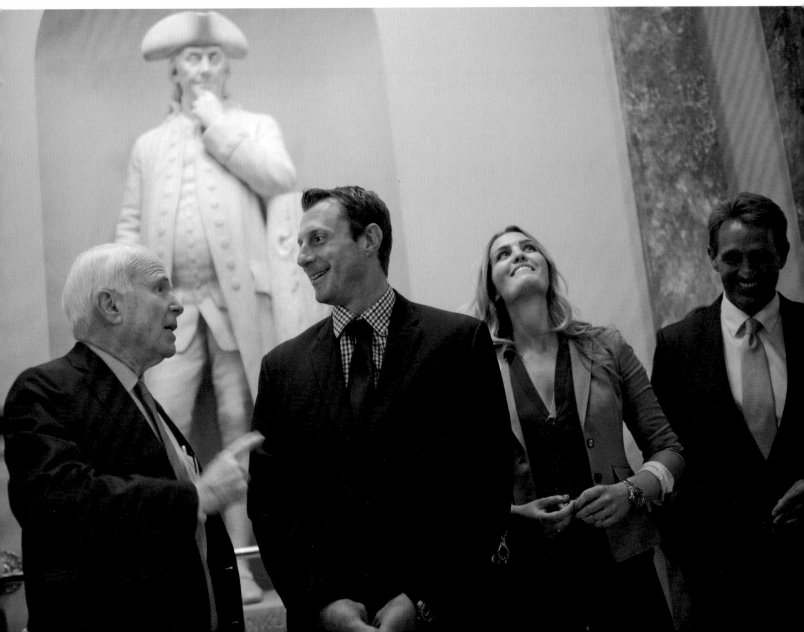

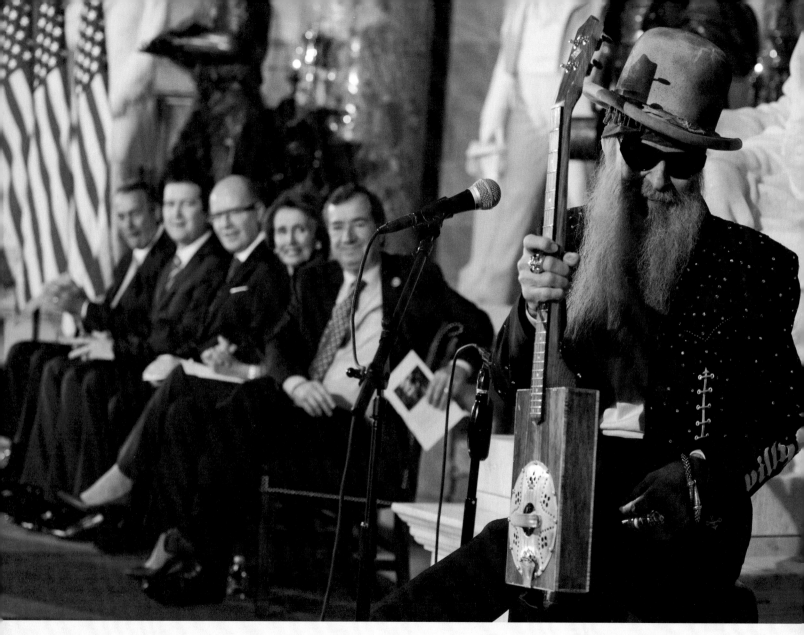

Billy Gibbons of ZZ Top performs during a ceremony unveiling the bust of the late Czech President Vaclav Havel, who was a fan of the Texas-based rock band. (Tom Williams)

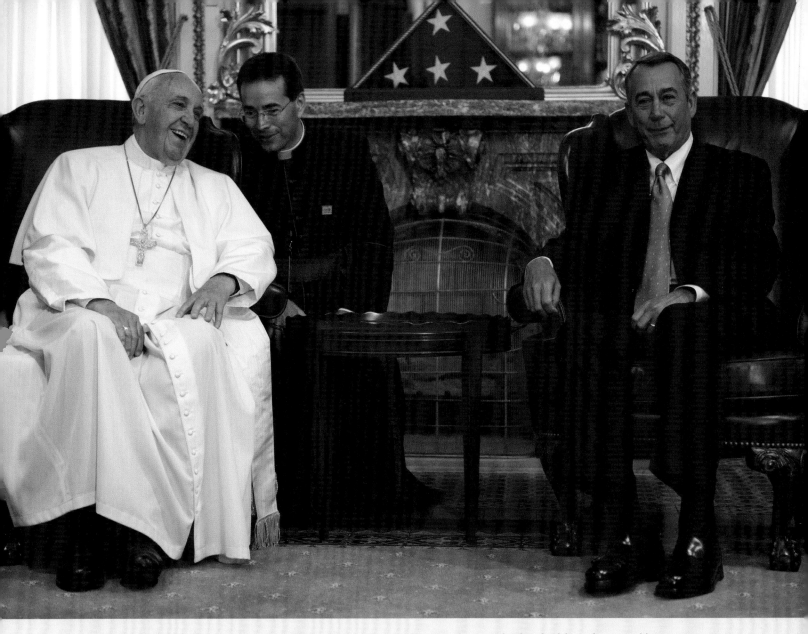

Pope Francis talks with Speaker John Boehner, R-Ohio, during the pontiff's visit to the Capitol, where he delivered a joint address to Congress and then spoke to a crowd assembled on the West Front and the National Mall. (Bill Clark)

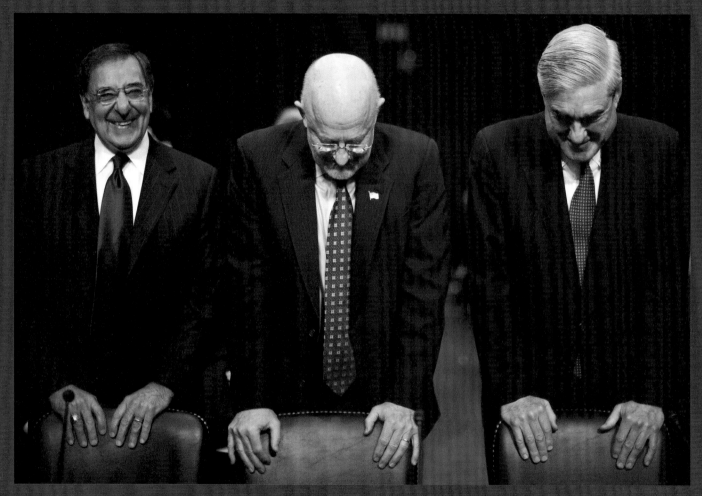

CIA Director Leon Panetta is all smiles before testifying alongside Director of National Intelligence James Clapper and FBI Director Robert Mueller.
(Bill Clark)

Joy

That sense of happiness, or pleasure or delight, as when you see old friends, or a cute dog.

Is the dog really smiling back? I don't know, but she sure seems to.

Maybe it's the feeling when you know, even if it's just for a short time, you're doing something with everyone else that has no other purpose than to simply have fun.

Like wearing seersucker suits, the very comfortable and very odd outfits made for hot days but that make everyone look like they are old-timey ice cream salesmen.

Or what about the time you moved the giant stuffed bear and the giant stuffed moose into place so that everyone from New Hampshire would feel at home as they ate maple syrup pancakes and drank Granite State craft beers?

Maybe it's having fun with your mom, or welcoming back someone you were very, very worried about and didn't think you'd see again. And there he is, walking and talking and people are cheering.

And you know that everything is going to be all right.

★ ★

Members of Congress gather for the annual House Seersucker Day photo. Rep. Bill Cassidy, R-La., center, organized the day, which showcases the hot-weather fabric. (Bill Clark)

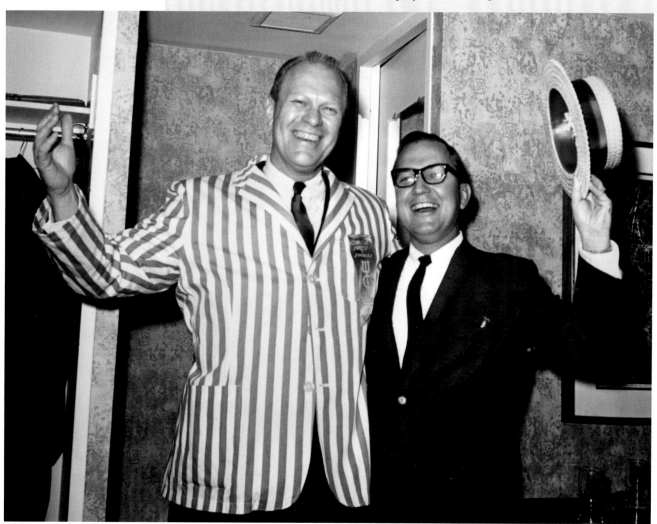

Rep. Gerald Ford, R-Mich., years before he became vice president and president, yuks it up with William Clay Ford, the Ford Motor Company executive. (CQ Roll Call)

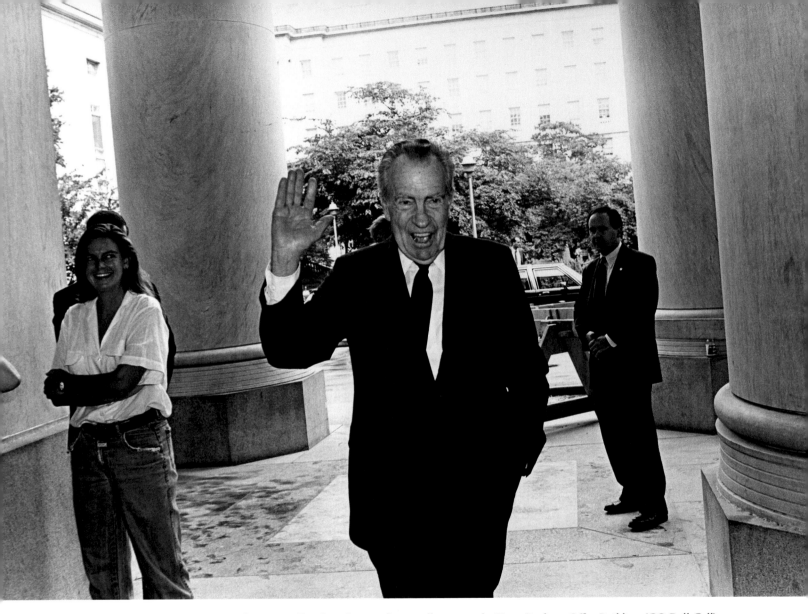

Former President Richard Nixon is all smiles as he visits former colleagues in the House Rayburn Office Building. (CQ Roll Call)

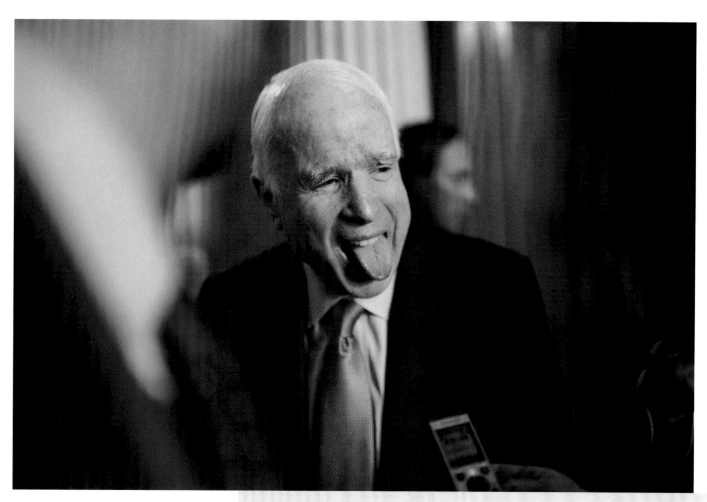

Sen. John McCain, R-Ariz., laughs at a reporter's question about whether a special prosecutor should investigate President Donald Trump. (Tom Williams)

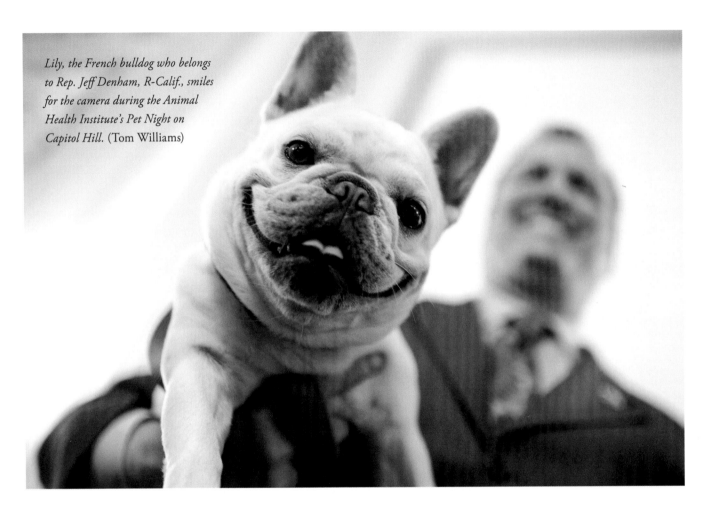

Lily, the French bulldog who belongs to Rep. Jeff Denham, R-Calif., smiles for the camera during the Animal Health Institute's Pet Night on Capitol Hill. (Tom Williams)

Scott Merrick, left, and Kevin Travaline, staffers for Sen. Jeanne Shaheen, D-N.H., move a stuffed bear into position next to a stuffed moose in the Hart Senate Office Building as they prepare for the Experience New Hampshire event in the nearby Russell Senate Office Building. (Bill Clark)

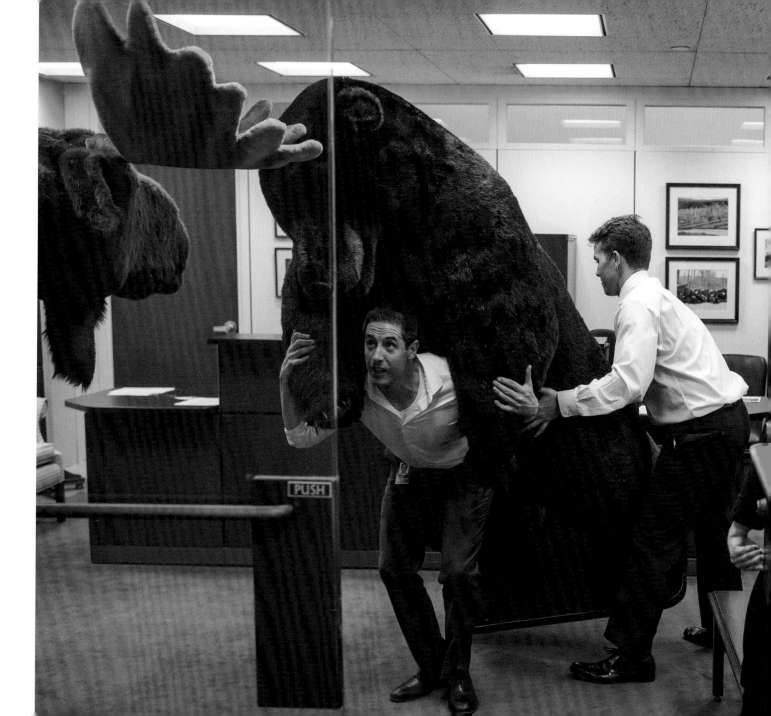

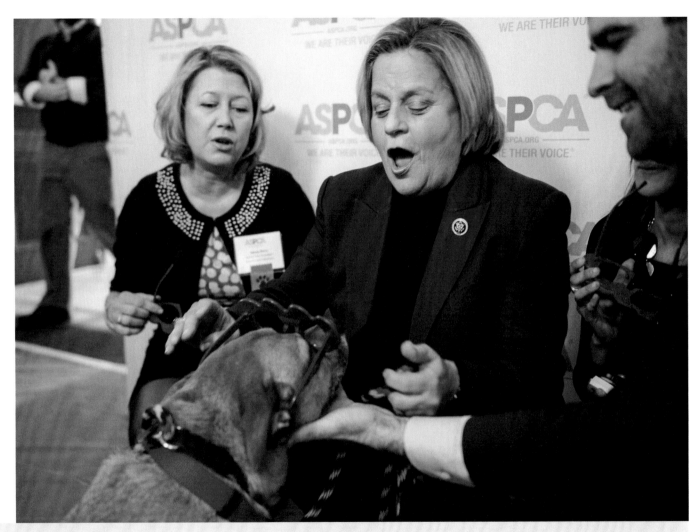

Nancy Perry, an executive with the American Society for the Prevention of Cruelty to Animals, looks on as Rep. Ileana Ros-Lehtinen, R-Fla., puts heart glasses on a dog at the annual ASPCA Paws for Love event on Capitol Hill. (Bill Clark)

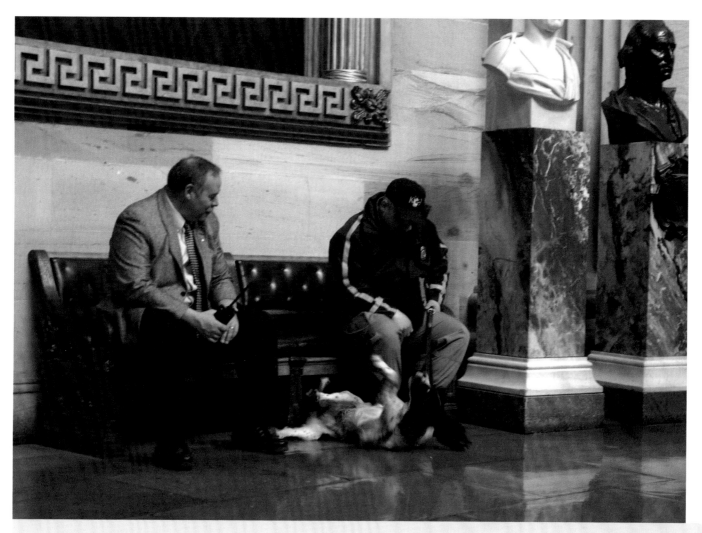

Sammy the Capitol Police dog plays with technician Michael Rodwill during a break between security sweeps at the Capitol before the annual St. Patrick's Day lunch. (Tom Williams)

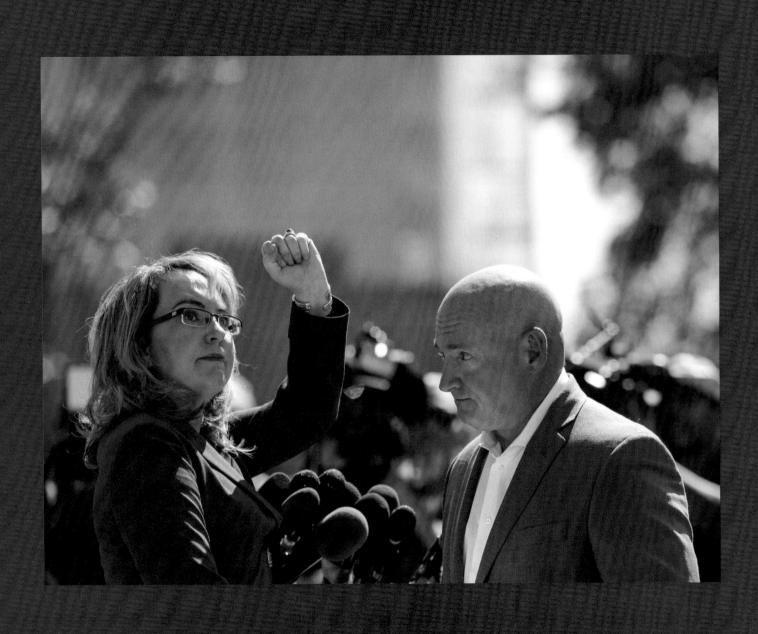

CHAPTER 8

Contempt

Contempt.

It's not just a vague sense of scorn to be directed at those beneath one's station. Contempt is a formal offense when directed at a court of law or, in the case of the legislative branch, Congress.

Contempt of Congress can be plagued by vagueness, too.

Congress has never really been held in very high regard throughout history, so being accused of contempt of Congress could, it can be argued, just be our natural state.

But Congress itself gets to decide who is in contempt of Congress.

It can be because someone didn't answer a subpoena.

Or wasn't forthcoming with documents or answers in a high-wire investigation.

Congress and its members get to decide what constitutes contempt, and sometimes even formally censure other government officials, private citizens, and even its own members for contempt.

The other kind of contempt, though? When a political opponent is coming to town or maybe a nosy reporter won't leave you alone?

That kind of contempt is written all over their faces.

★ ★

Former Rep. Gabrielle Giffords, D-Ariz., shakes her fist in frustration at the Capitol as her husband, retired Astronaut Mark Kelly, looks on at a press conference about the mass shooting in Las Vegas on October 1, 2017. Giffords and Kelly cofounded Americans for Responsible Solutions after Giffords was shot in the head by a constituent in 2011. The two of them have been frustrated that Congress has not passed legislation to respond to mass shootings. (Bill Clark)

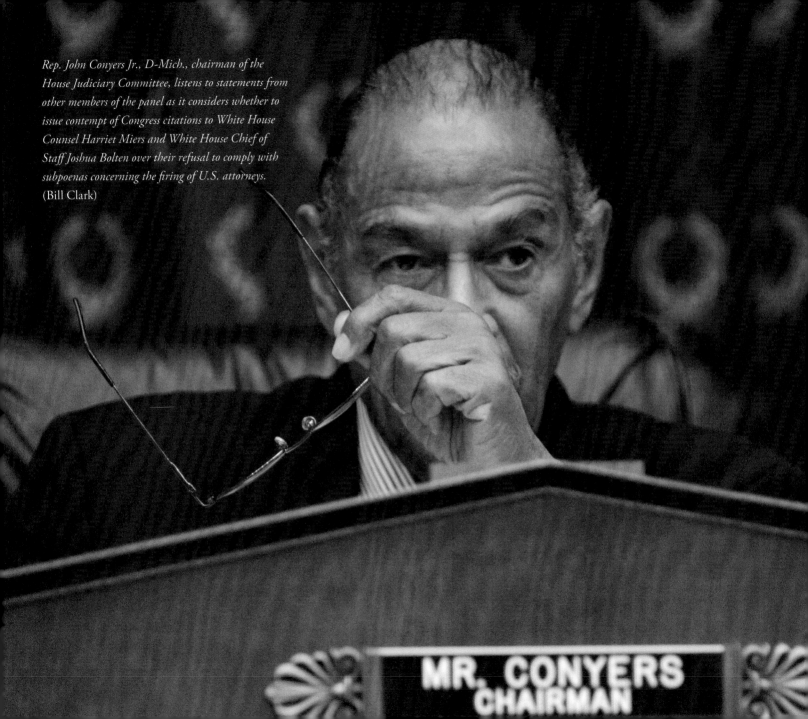

Rep. John Conyers Jr., D-Mich., chairman of the House Judiciary Committee, listens to statements from other members of the panel as it considers whether to issue contempt of Congress citations to White House Counsel Harriet Miers and White House Chief of Staff Joshua Bolten over their refusal to comply with subpoenas concerning the firing of U.S. attorneys. (Bill Clark)

MR. CONYERS
CHAIRMAN

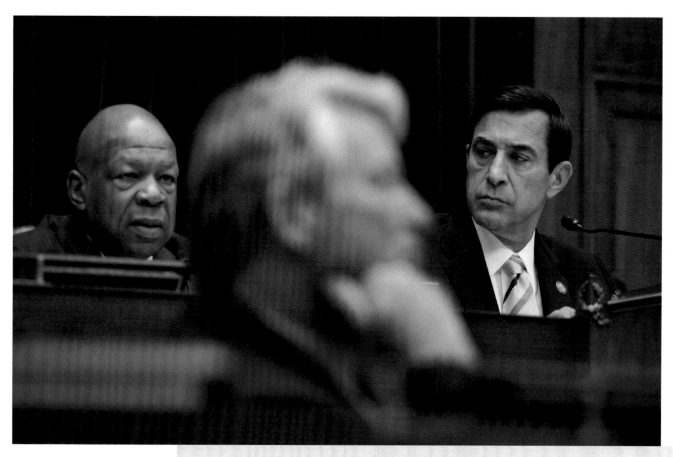

House Oversight and Government Reform Chairman Darrell Issa, R-Calif., right, listens to Rep. Elijah E. Cummings of Maryland, the panel's top Democrat, as Cummings makes opening statements as the panel considers holding Attorney General Eric Holder in contempt of Congress. (Tom Williams)

Attorney General Alberto Gonzales testifies before the Senate Judiciary Committee over the firing of U.S. attorneys. Gonzales came under fire himself for not being forthright with Congress and eventually resigned. (Bill Clark)

House Minority Leader Nancy Pelosi, D-Calif., prepares to discuss the visit of then-candidate Donald Trump to the Capitol shortly after Trump secured the GOP nomination for president. (Bill Clark)

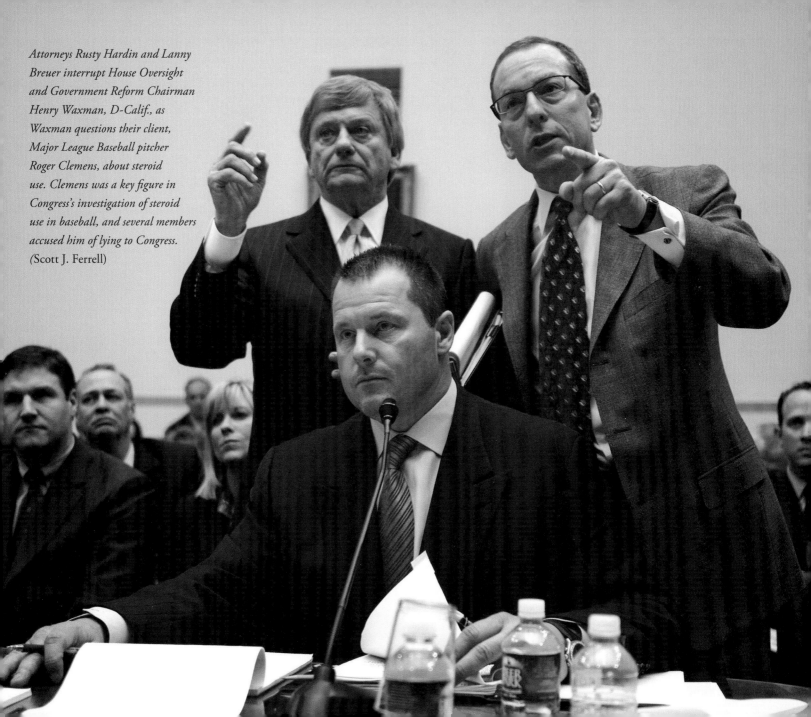

Attorneys Rusty Hardin and Lanny Breuer interrupt House Oversight and Government Reform Chairman Henry Waxman, D-Calif., as Waxman questions their client, Major League Baseball pitcher Roger Clemens, about steroid use. Clemens was a key figure in Congress's investigation of steroid use in baseball, and several members accused him of lying to Congress. (Scott J. Ferrell)

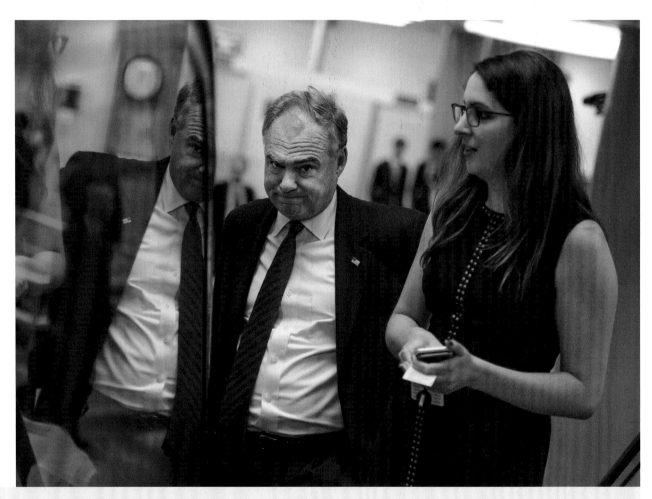

Sen. Tim Kaine, D-Va., does not look like he is in the mood to be questioned by reporters as he makes his way to the Senate policy luncheons in the Capitol. (Tom Williams)

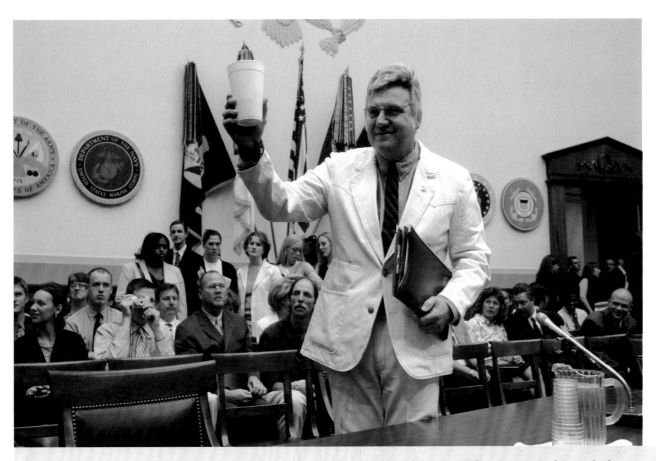

Rep. James Traficant, D-Ohio, tips his cup of soda to the cameras before he addressed the House Ethics Committee about multiple corruption charges against him. Traficant, who rarely missed an opportunity to flout authority, was found guilty of violating House rules, and his colleagues recommended expulsion from Congress. His colleagues eventually did expel him from the body, and he later went to prison after being convicted of corruption. (Tom Williams)

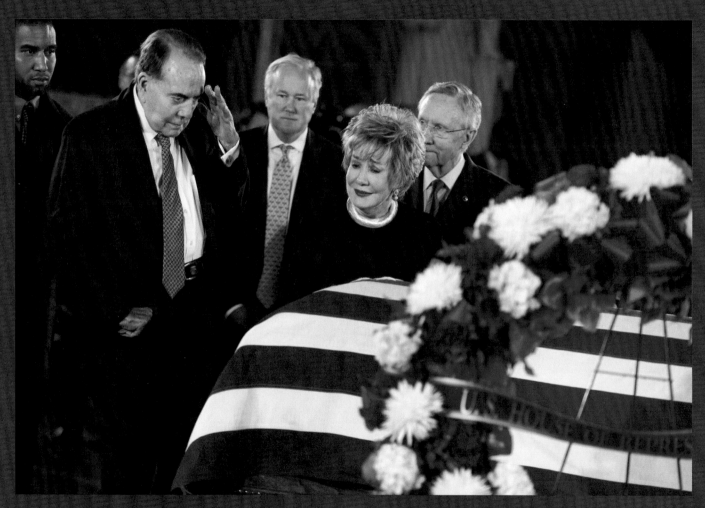

Former Sen. Bob Dole, R-Kan., salutes the casket of the late Sen. Daniel Inouye, D-Hawaii, as Inouye's body lay in state in the Capitol Rotunda. The friendship of Dole and Inouye dates to World War II, when the two recuperated at Walter Reed Medical Center from grave injuries they suffered on the battlefield. Dole was assisted to the casket, saying, "I wouldn't want Danny to see me in a wheelchair." (Tom Williams)

CHAPTER 9

Grief

There are few places where grief comes into such a consistently public focus as the Capitol.

Relatively few people actually know a president or senator or representative or cultural figure on a personal level.

But when a Rosa Parks or a Ronald Reagan dies, it affects everyone, from the family left behind to the millions who admired them.

Grief touches us all.

We mourn our loved ones. But we seldom have to do so under the glare of a camera or the eyes of a nation needing comfort as well.

So the Capitol is an unusual place: It is where public and private grief commingle, among colleagues and strangers, and where everyone has some kind of connection in the body politic.

Public service creates a bond among the servants and the served.

When death comes, as it does for everyone, caused by everything from old age to violent clash, it affects us all differently.

But the common ground of the Capitol provides a grieving space for everyone from the highest-profile politician to the virtually anonymous constituent.

★ ★

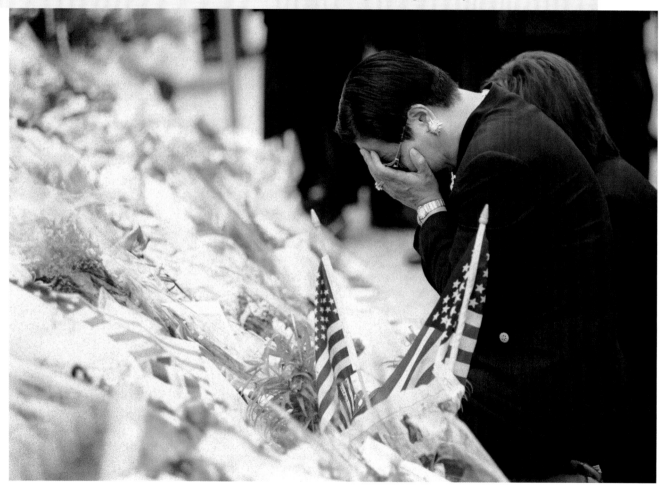

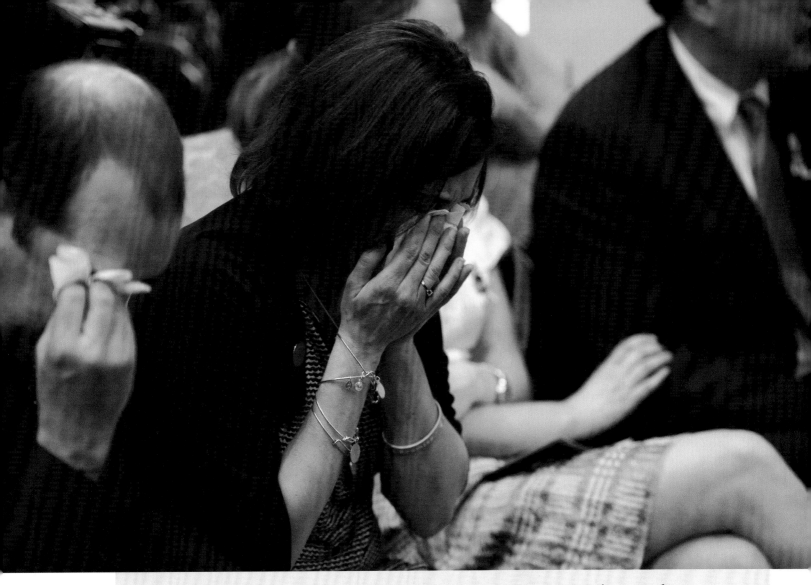

Families of the shooting victims at Sandy Hook Elementary School in Newtown, Connecticut, meet to discuss gun safety legislation in the office of Sen. Joe Manchin III, D-W.Va., in the Hart Senate Office Building. (Douglas Graham)

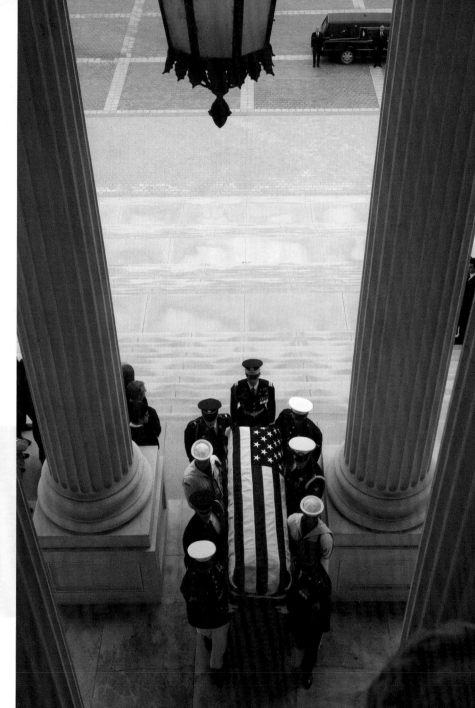

The Army Old Guard carries the casket of the late Sen. Frank Lautenberg, D-N.J., a World War II veteran, up the Capitol steps, where Lautenberg's body would lie in repose.
(Douglas Graham)

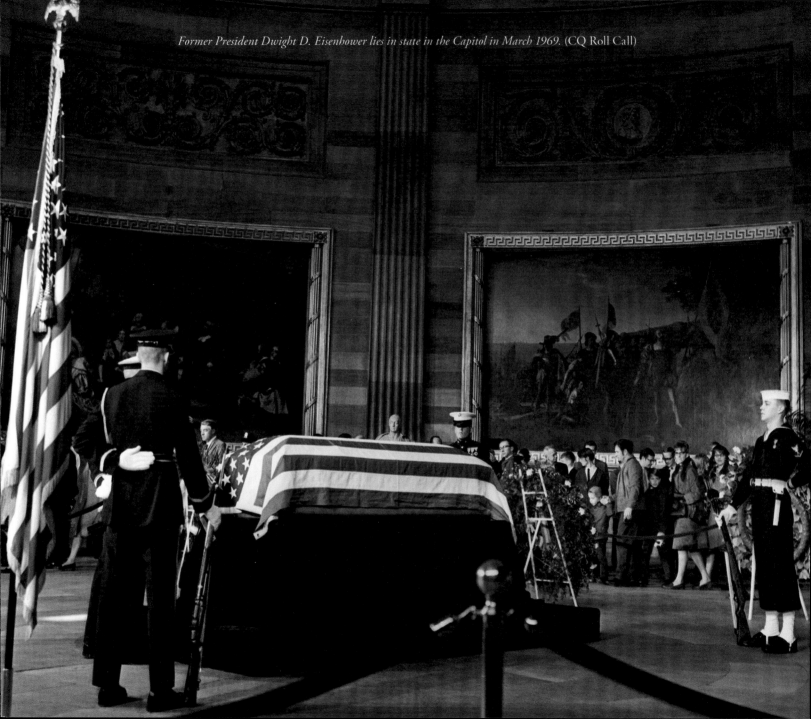

Former President Dwight D. Eisenhower lies in state in the Capitol in March 1969. (CQ Roll Call)

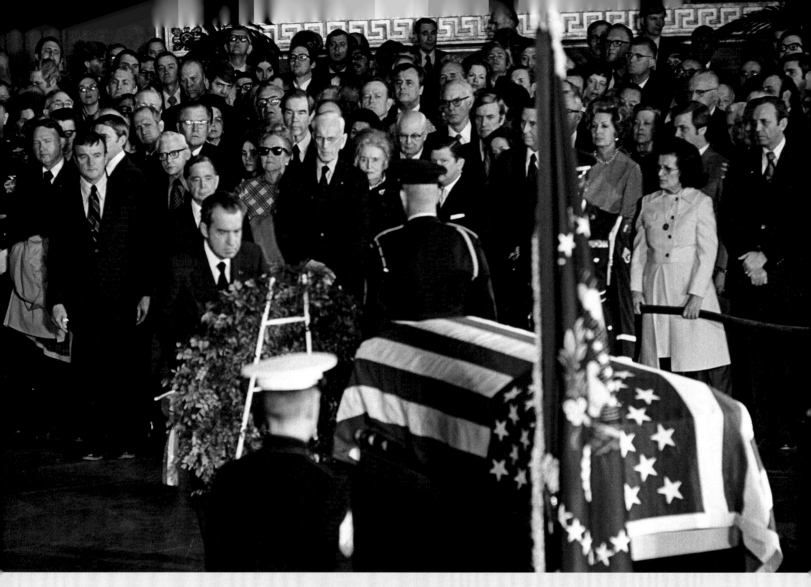

President Richard M. Nixon leads mourners as he surveys the wreath adorning the casket of former President Lyndon Baines Johnson in the Capitol. Johnson was the vice presidential candidate for John F. Kennedy, who defeated Nixon for the presidency in 1960. (Dev O'Neill)

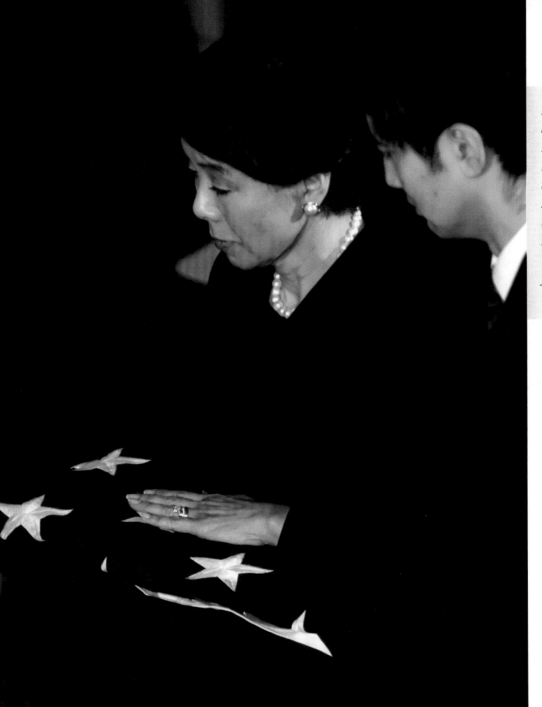

Doris Matsui, the widow of Rep. Robert Matsui, D-Calif., and their son Brian receive a flag at the congressman's memorial service in the Capitol's Statuary Hall. Doris Matsui would go on to win a special election to fill his congressional seat. (Chris Maddaloni)

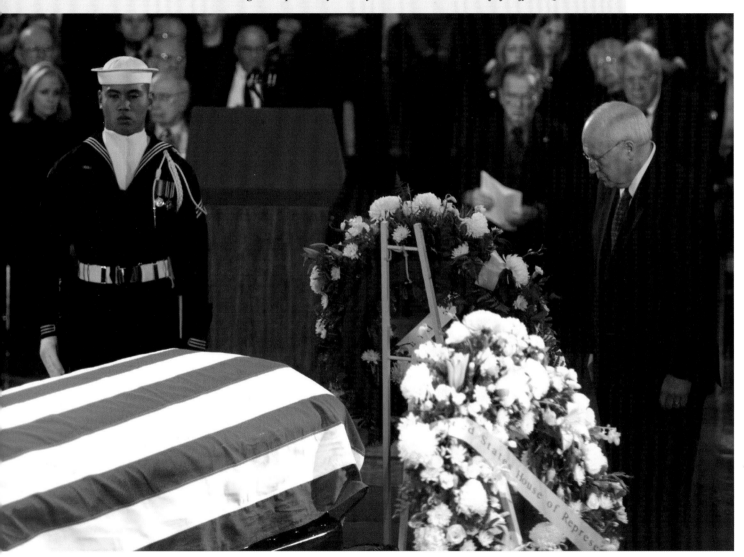

Vice President Dick Cheney pauses after laying a wreath at the state funeral in the Capitol Rotunda for former President Gerald Ford. During Ford's presidency, Cheney was his White House chief of staff. (CQ Roll Call)

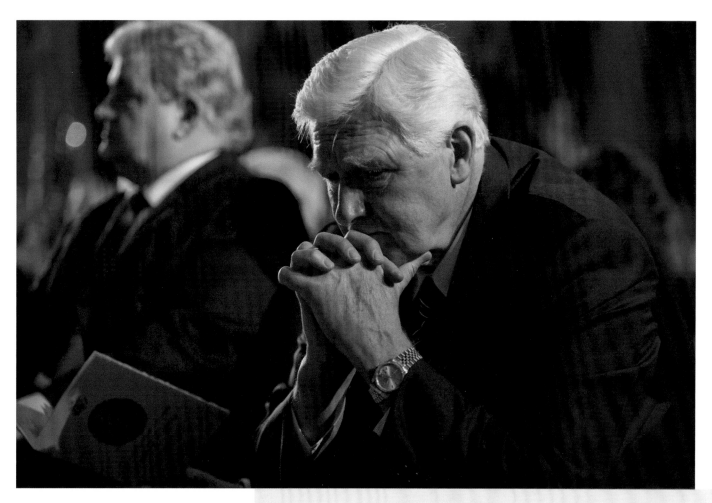

Rep. Jim Moran, D-Va., attends the memorial service in the Capitol's Statuary Hall for his longtime colleague, Rep. John Murtha, D-Pa. (Tom Williams)

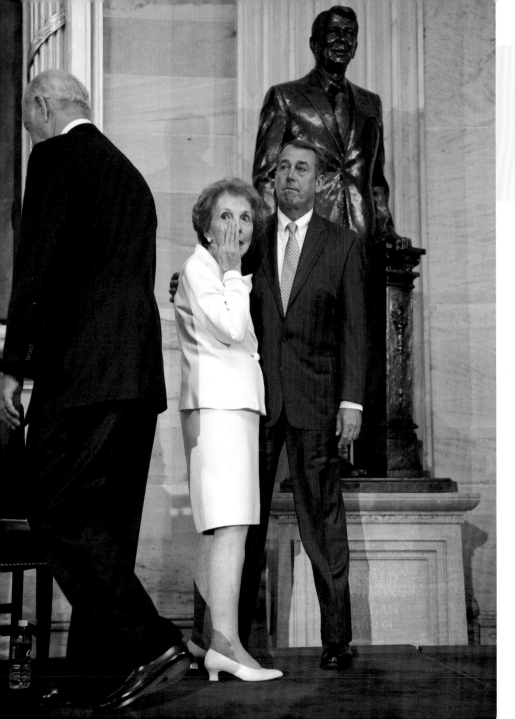

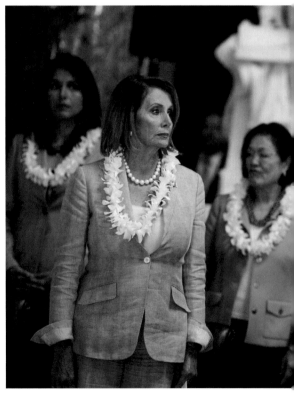

Rep. John Boehner, R-Ohio, comforts former First Lady Nancy Reagan during the ceremony unveiling the statue of her late husband, President Ronald Reagan, in the Capitol's Statuary Hall. James Baker, Reagan's former Treasury secretary and chief of staff, is also pictured. (Bill Clark)

Civil rights activist Rosa Parks lies in state in the Rotunda of the Capitol. (Chris Maddaloni)

From left, Rep. Tulsi Gabbard, D-Hawaii, House Minority Leader Nancy Pelosi, D-Calif., Sen. Mazie Hirono, D-Hawaii, Speaker Paul D. Ryan, R-Wis., and Sen. Brian Schatz, D-Hawaii, attend a memorial service for the late Rep. Mark Takai, D-Hawaii, in the Capitol's Statuary Hall. (Tom Williams)

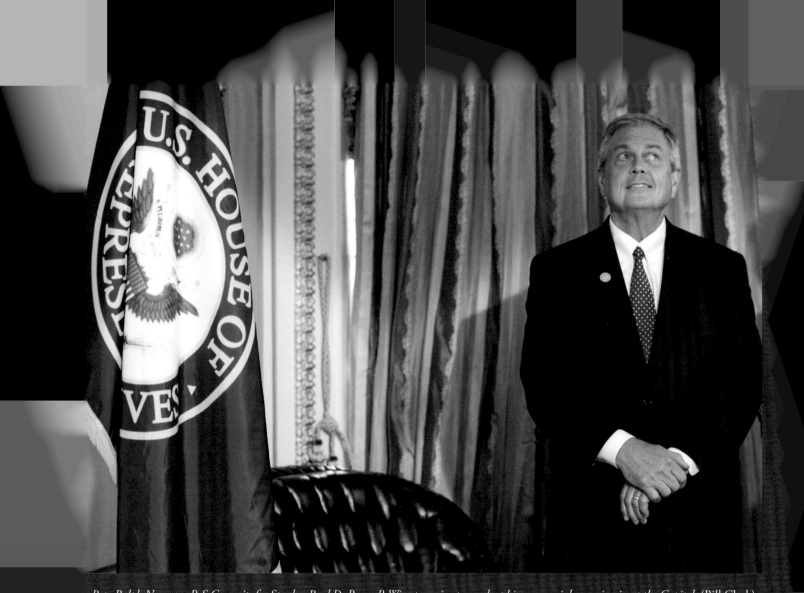

Rep. Ralph Norman, R-S.C., waits for Speaker Paul D. Ryan, R-Wis., to arrive to conduct his ceremonial swearing in at the Capitol. (Bill Clark)

Anticipation

Carly Simon sang it right:

"Anticipation is makin' me late, is keepin' me waitin.'"

And around the Capitol, there is always plenty of it to go around.

If you're a new member of Congress, and you've just been sworn in on the House floor, you'll be shuffled off to wait in another room, where you'll wait for the Speaker to conduct his ceremonial swearing in, the one where you get to bring the grandkids and have a picture taken.

Are you president of the United States?

Sometimes the cheers get so loud and long, you'll be waiting, and might even have to quiet the crowd, before you get to deliver your State of the Union address.

Maybe you're even the vice president, or a senator, and wondering where everyone's at.

Check that watch.

Where is everybody?

It's keepin' me waitin'.

Sometimes, though, it's worth just looking out, pausing a moment, taking it all in.

Something big is about to start.

A session of Congress.

A hearing.

A presidency.

Sometimes it's worth keepin' them waitin'.

★ ★

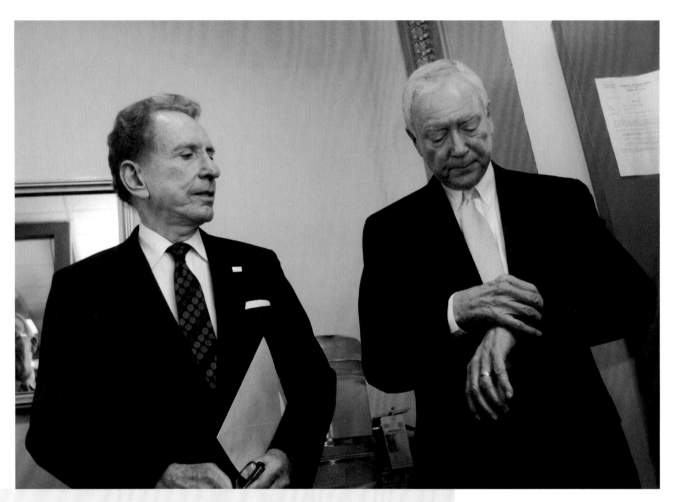

*Sen. Orrin G. Hatch, R-Utah, checks his watch as he and Sen. Arlen Specter, R-Pa.,
wait for the their colleagues to arrive at a press conference.* (Scott J. Ferrell)

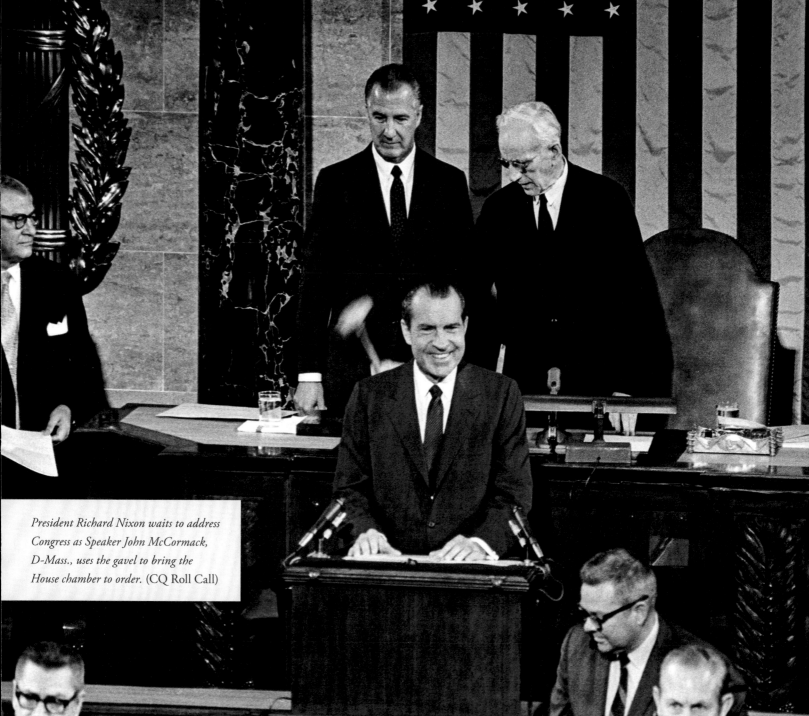

President Richard Nixon waits to address Congress as Speaker John McCormack, D-Mass., uses the gavel to bring the House chamber to order. (CQ Roll Call)

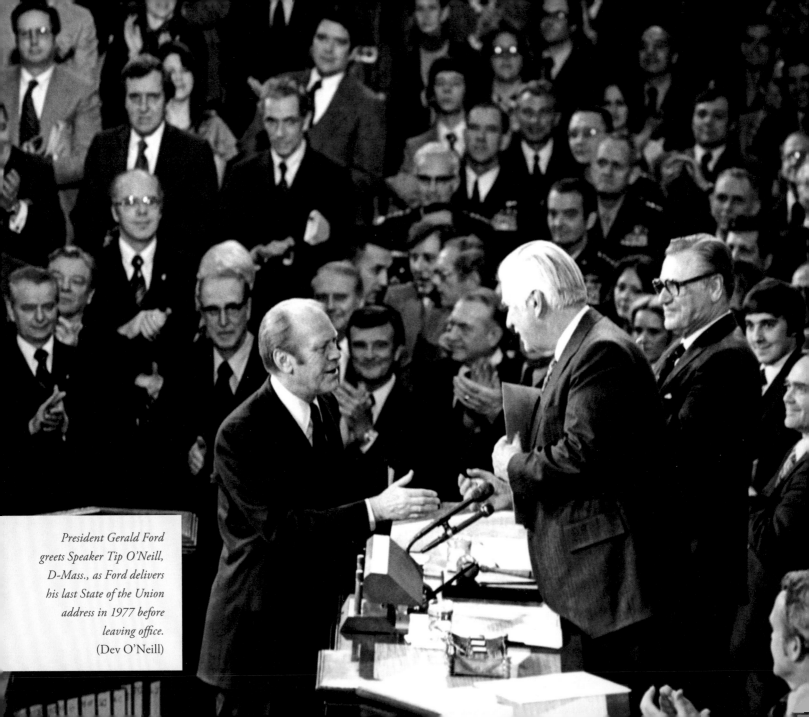

President Gerald Ford greets Speaker Tip O'Neill, D-Mass., as Ford delivers his last State of the Union address in 1977 before leaving office.
(Dev O'Neill)

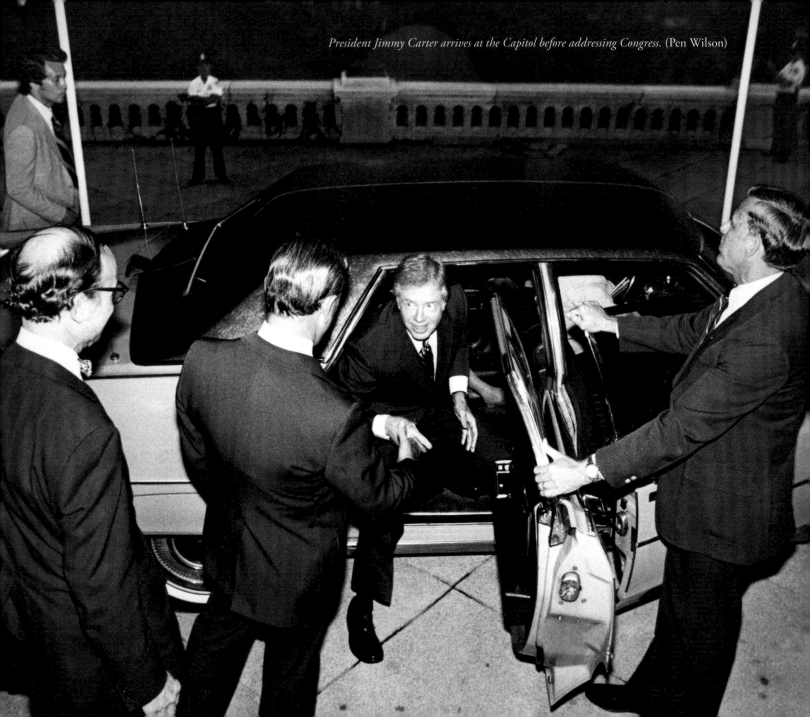

President Jimmy Carter arrives at the Capitol before addressing Congress. (Pen Wilson)

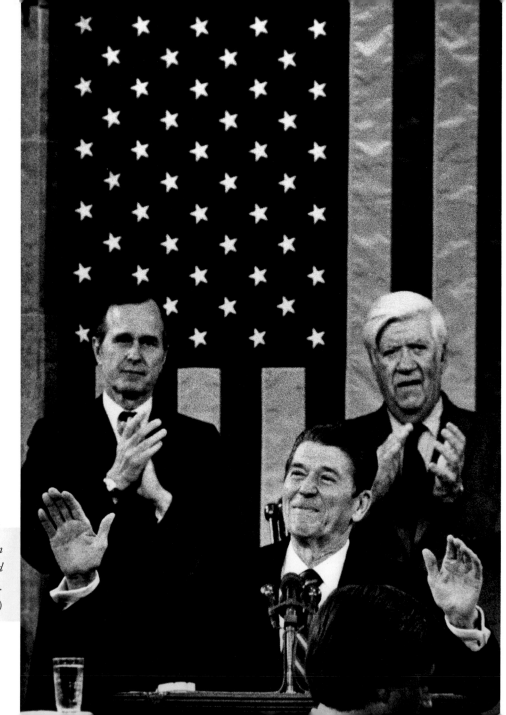

President Ronald Reagan tries to tamp down the crowd before addressing Congress.
(CQ Roll Call)

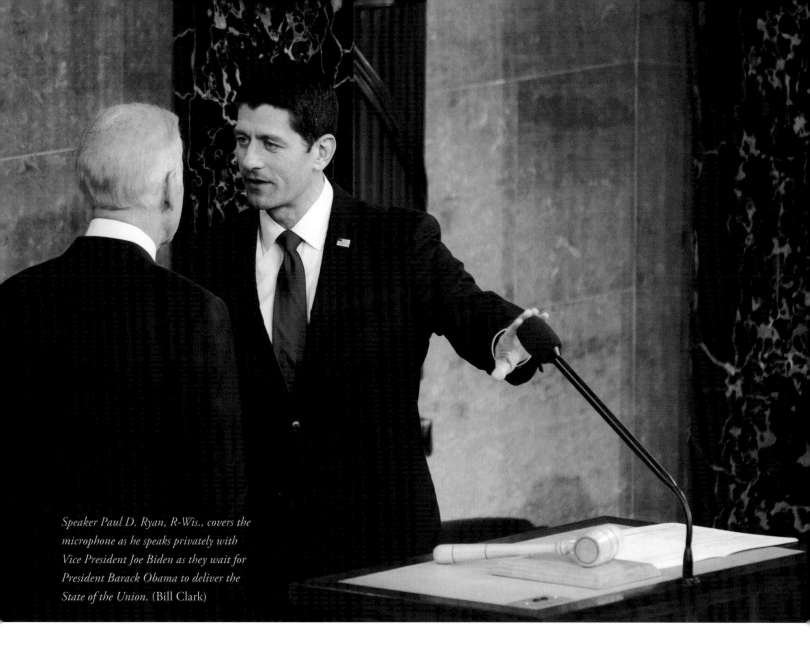

Speaker Paul D. Ryan, R-Wis., covers the microphone as he speaks privately with Vice President Joe Biden as they wait for President Barack Obama to deliver the State of the Union. (Bill Clark)

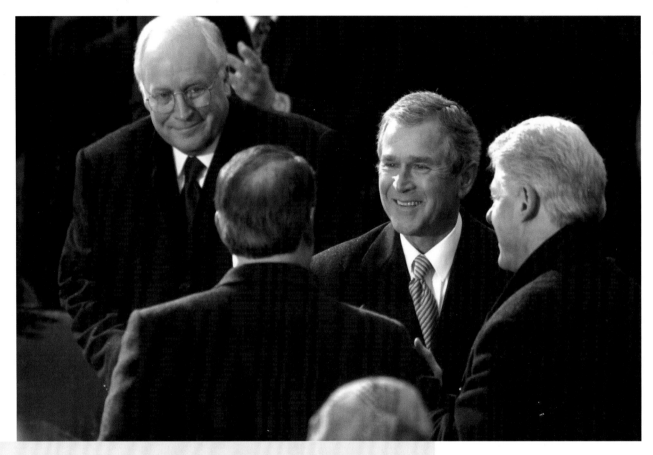

President George W. Bush greets former Vice President Al Gore, the man whom he defeated in the 2000 election, after being sworn in to office. (Douglas Graham)

President Barack Obama, the nation's first black president, at his inaugural address at the West Front of the Capitol. (Scott J. Ferrell)

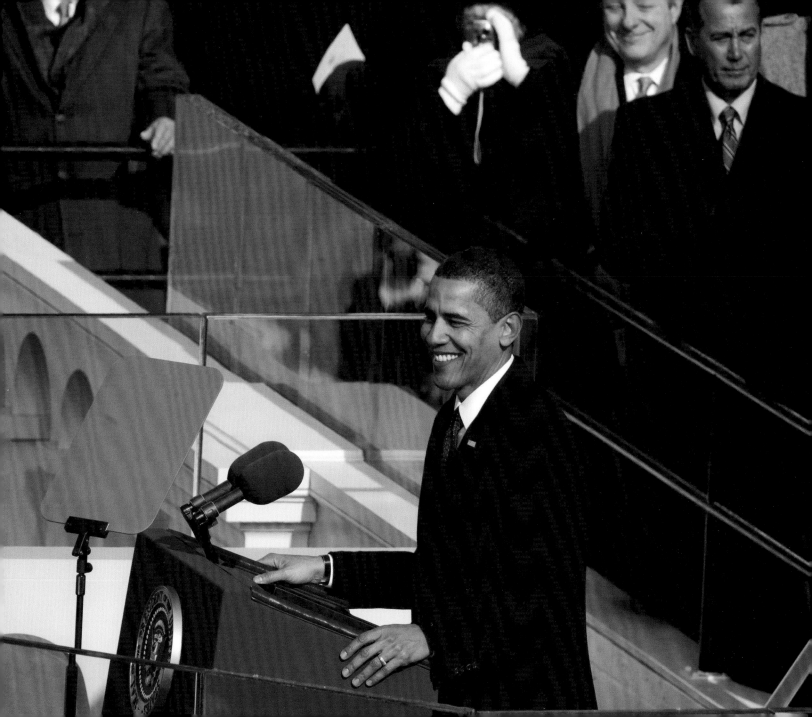

The view from inside the Capitol as President Donald Trump addresses the crowd at his inauguration after being sworn in.
(Tom Williams)

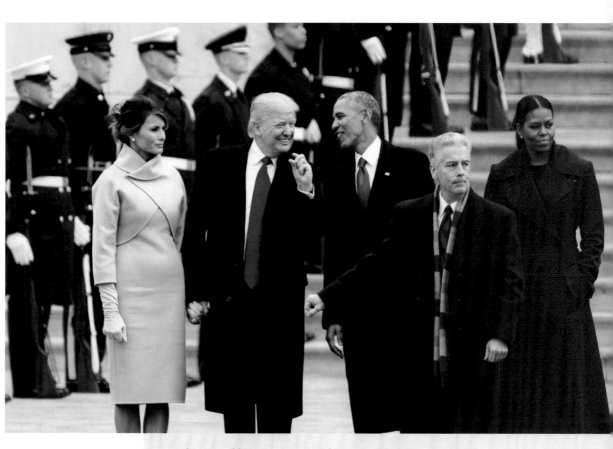

President Donald Trump gestures to former President Barack Obama as they depart the Capitol after Trump was sworn in. (Bill Clark)

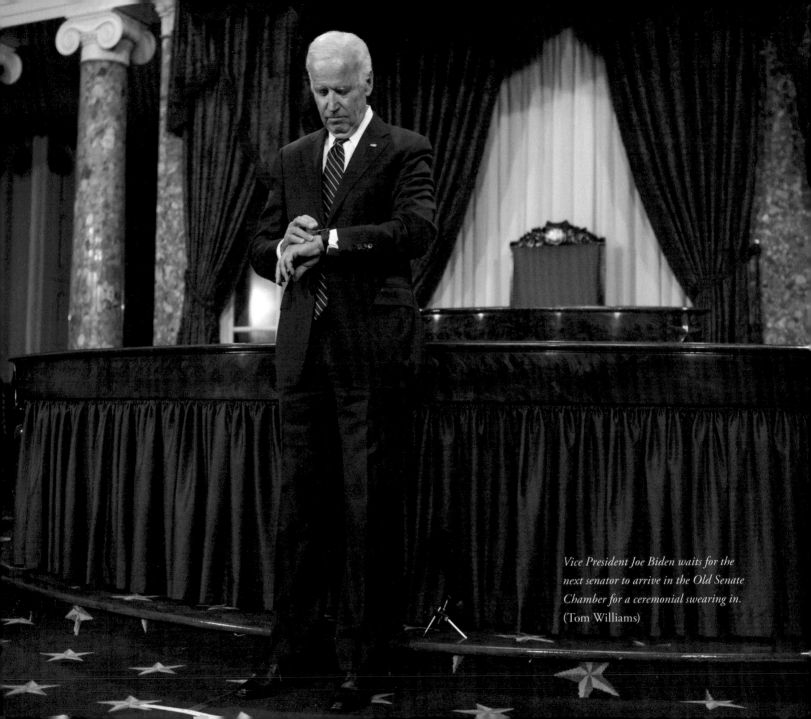

Vice President Joe Biden waits for the next senator to arrive in the Old Senate Chamber for a ceremonial swearing in. (Tom Williams)

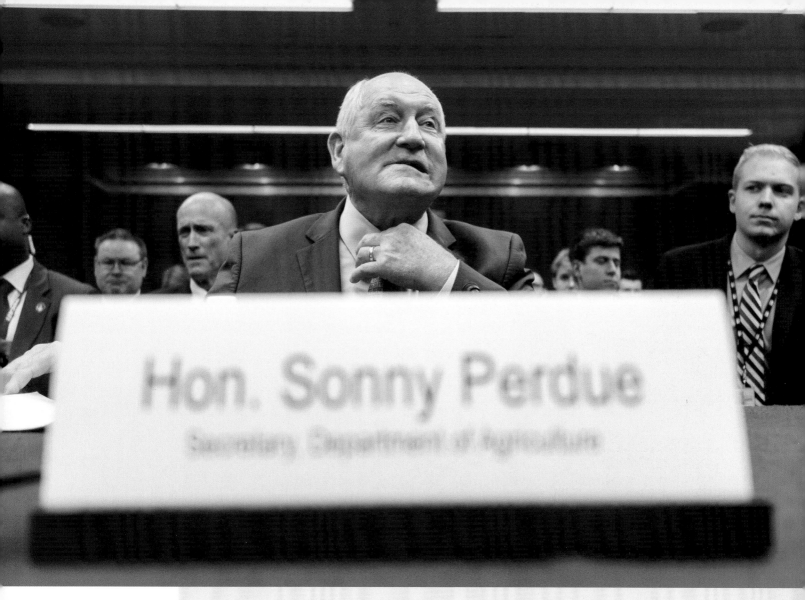

Agriculture Secretary Sonny Perdue gets ready to testify about his department's budget request. (Bill Clark)

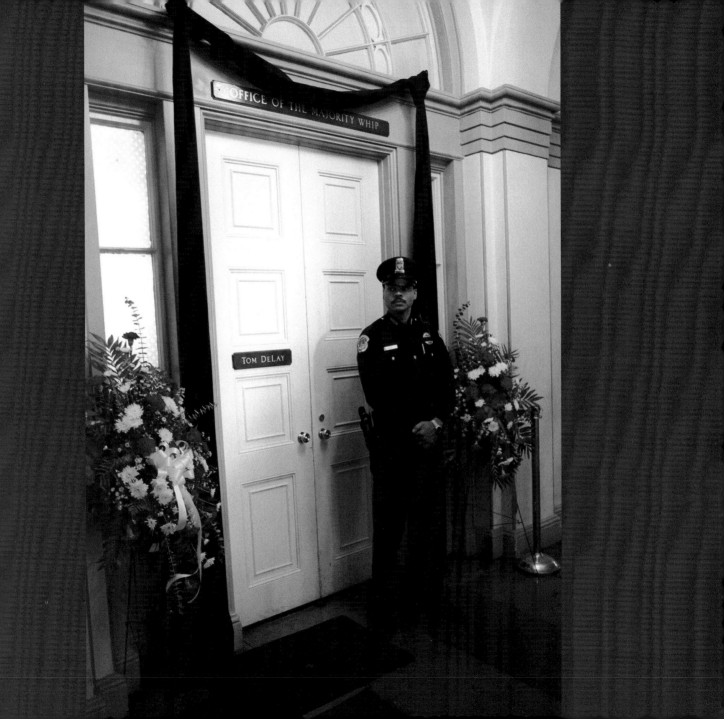

Terror

What makes the U.S. Capitol so compelling also, unfortunately, makes it a target.

The images from the September 11, 2001, terrorist attacks, for instance, are seared into the American consciousness, particularly as the World Trade Center towers fell and the Pentagon burned.

Terror gripped the Capitol as well that day. We may never know if the Capitol was the target of the downed United Flight 93, but the precautions that took over that day assumed the very worst.

Such days seized by terror have been anything but isolated.

The years before and after 9/11 have seen the Capitol and its community endure deadly shootings, an anthrax attack, even an earthquake that shook the place to the core—and necessitated a rare meeting of Congress outside the Capitol building.

It's not easy to live with the fact that you are a target, or you work at a target. But it is the reality for members, staff, and visitors.

Sometimes the terror can lead to fear.

Sometimes to resignation.

Sometimes to grind-it-out perseverance.

But it never goes away.

★ ★

Capitol Police Officer E. L. Boggs guards the door of the office of House Majority Whip Tom DeLay, R-Tex., in the days after Detective John Gibson and Officer Jacob J. Chestnut were killed protecting DeLay when gunman Russell Weston stormed into the office to target the whip. (Scott J. Ferrell)

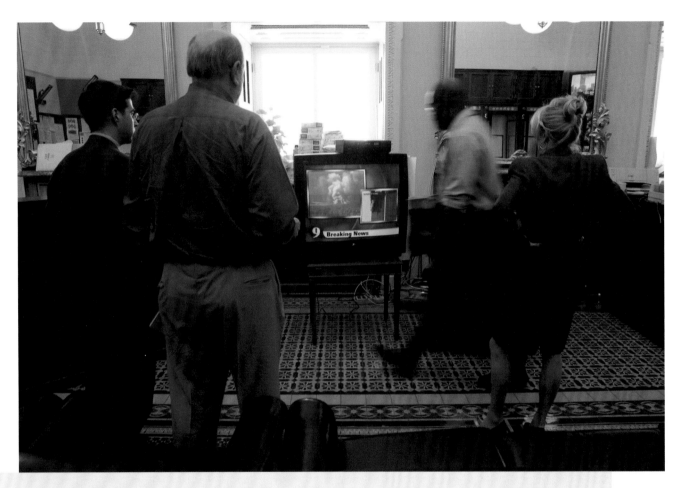

Staff and journalists in the Senate Daily Press Gallery watch the early reports on the morning of September 11, 2001, shortly before getting the order to evacuate the Capitol amid concerns a plane would target the building. (Tom Williams)

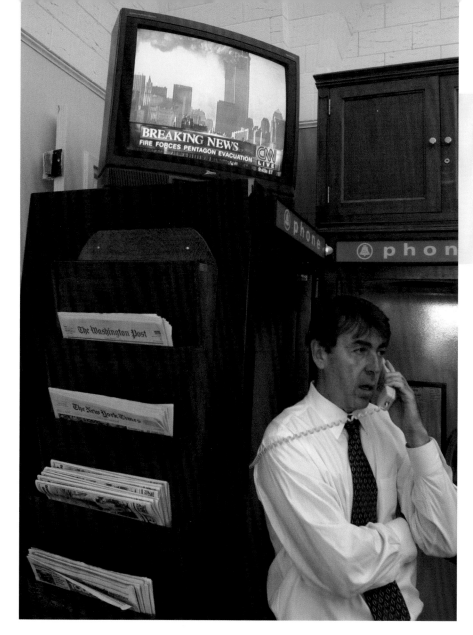

Joe Keenan, director of the Senate Daily Press Gallery, gathers information on the terrorist attacks in New York and Washington on September 11, 2001, just before the order went out to evacuate the building amid concerns it, too, was a target. (Tom Williams)

People, including Sen. Chuck Grassley, R-Iowa, in the red tie, evacuate the Capitol building on the morning of September 11, 2001. Confusion ran amuck as government officials were unsure if the Capitol was another target for attack. While congressional leaders were whisked away by their protective details to undisclosed locations, the overwhelming majority of members of Congress, staffers, visitors, and the like were left on their own to pursue safety. (Douglas Graham)

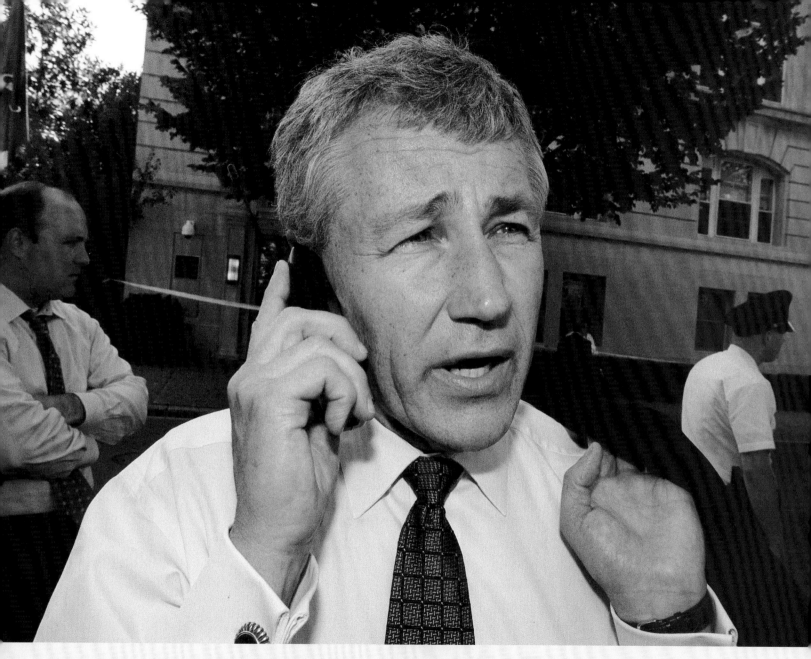

Sen. Chuck Hagel, R-Neb., does a phone interview amid the confusion of the September 11, 2001, attacks. Members did not know where to go after they received the order to evacuate, so many congregated around the Capitol buildings and tried to keep their constituents and the press informed. (Scott J. Ferrell)

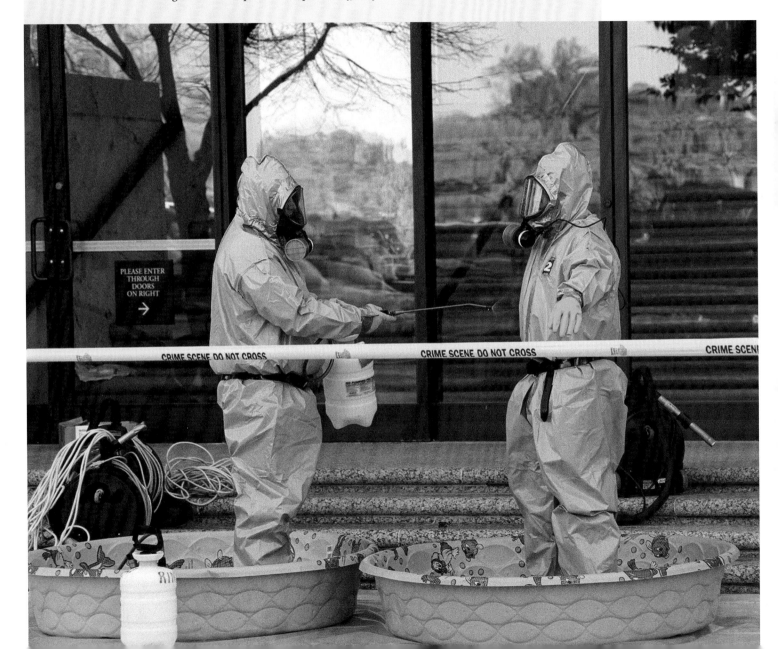

Workers rinse each other off after exiting the Hart Senate Office Building, which was closed for decontamination after a letter containing anthrax was opened in the personal office of Sen. Tom Daschle, D-S.D. (Scott J. Ferrell)

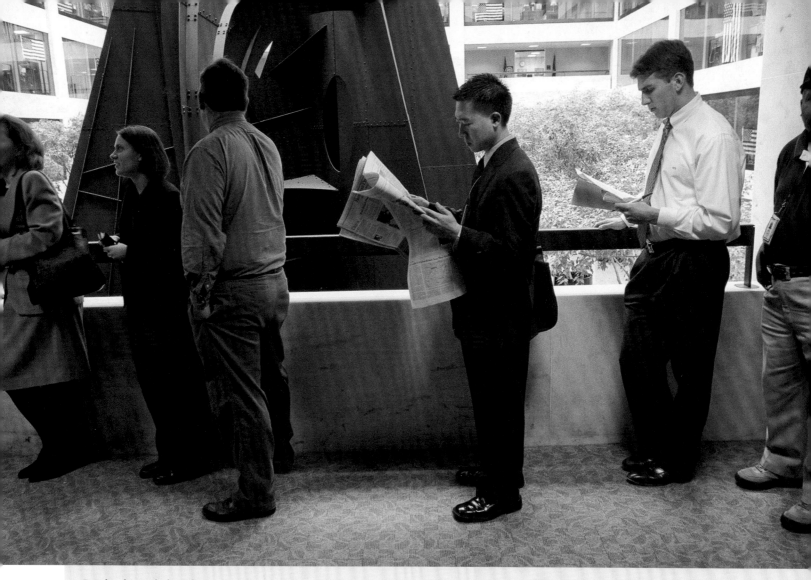

People who might have been exposed to anthrax spores in the Hart Senate Office Building wait to be tested. For many members and staffers, the risk of exposure was great enough that they had to take Cipro, a drug designed to counter the deadly anthrax bacteria. (Scott J. Ferrell)

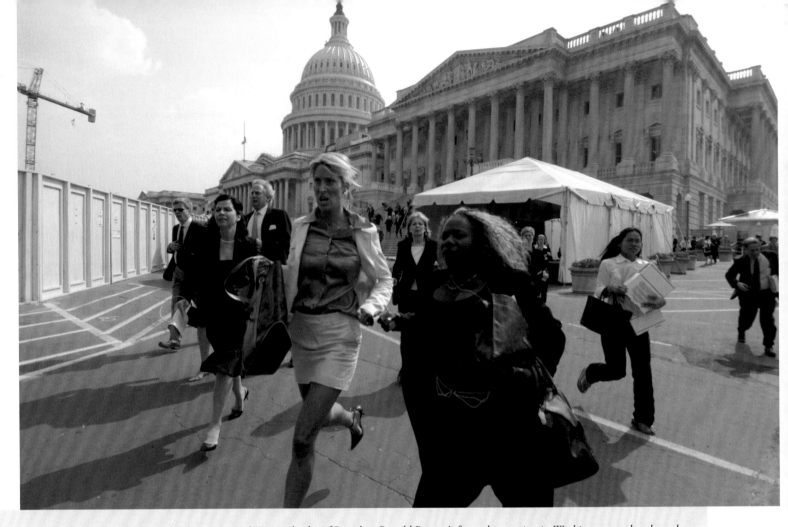

People evacuate the Capitol on June 9, 2004. It was the day of President Ronald Reagan's funeral procession in Washington, and a plane that air traffic controllers could not communicate with entered restricted D.C. airspace. With memories of 9/11 still raw, Capitol Police ordered the Capitol evacuated. It turned out to be a small plane carrying the governor of Kentucky, former Republican Rep. Ernie Fletcher, who was coming to town for Reagan's services. Although it was a false alarm, the sense of terror was real. (Douglas Graham)

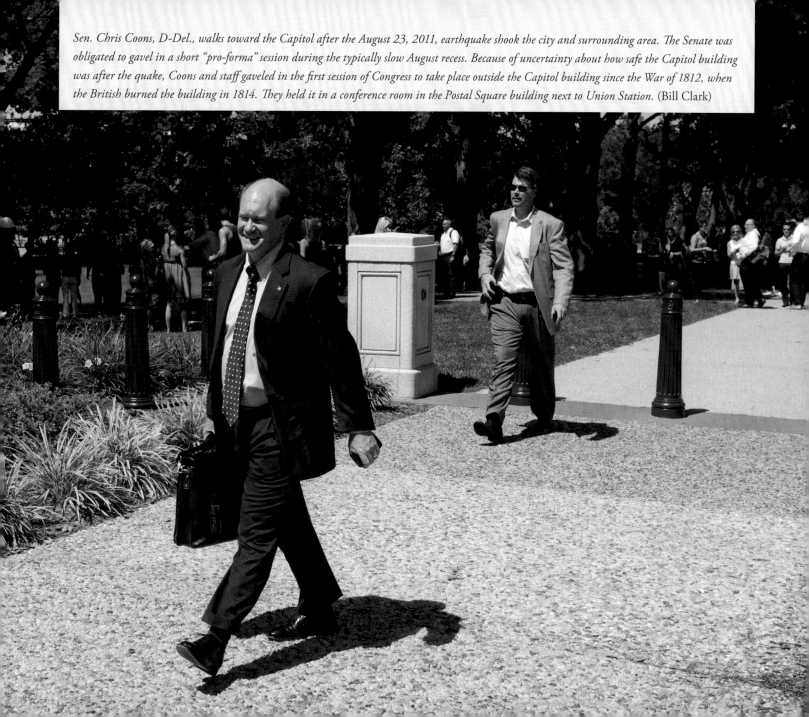

Sen. Chris Coons, D-Del., walks toward the Capitol after the August 23, 2011, earthquake shook the city and surrounding area. The Senate was obligated to gavel in a short "pro-forma" session during the typically slow August recess. Because of uncertainty about how safe the Capitol building was after the quake, Coons and staff gaveled in the first session of Congress to take place outside the Capitol building since the War of 1812, when the British burned the building in 1814. They held it in a conference room in the Postal Square building next to Union Station. (Bill Clark)

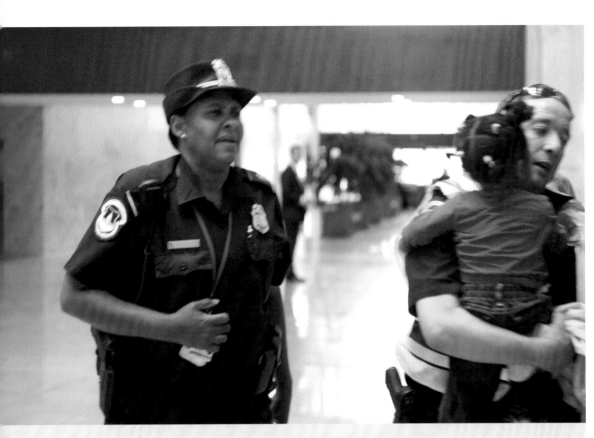

On October 3, 2013, Capitol Police shot and killed Miriam Carey after a car chase around the White House and Capitol complex. Carey's daughter Erica, pictured here, was evacuated from the scene by Capitol Police officers after the incident, which played out under a Capitol lockdown and the crack of more than twenty-six bullets. (Douglas Graham)

Senate staffers gather in their predesignated evacuation meeting spot in Upper Senate Park, across from the Capitol building, after a magnitude 5.9 earthquake struck the region. (Bill Clark)

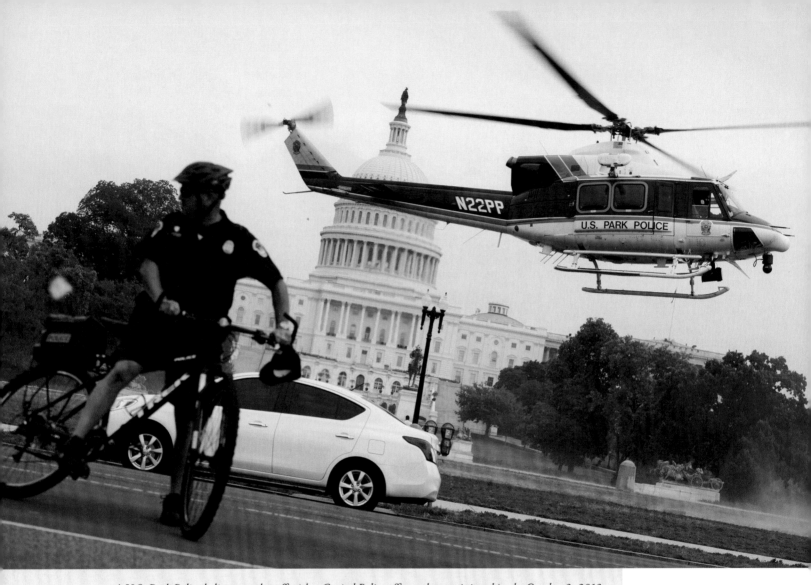

A U.S. Park Police helicopter takes off with a Capitol Police officer who was injured in the October 3, 2013, car chase and shooting of Miriam Carey on the Capitol grounds. (Tom Williams)

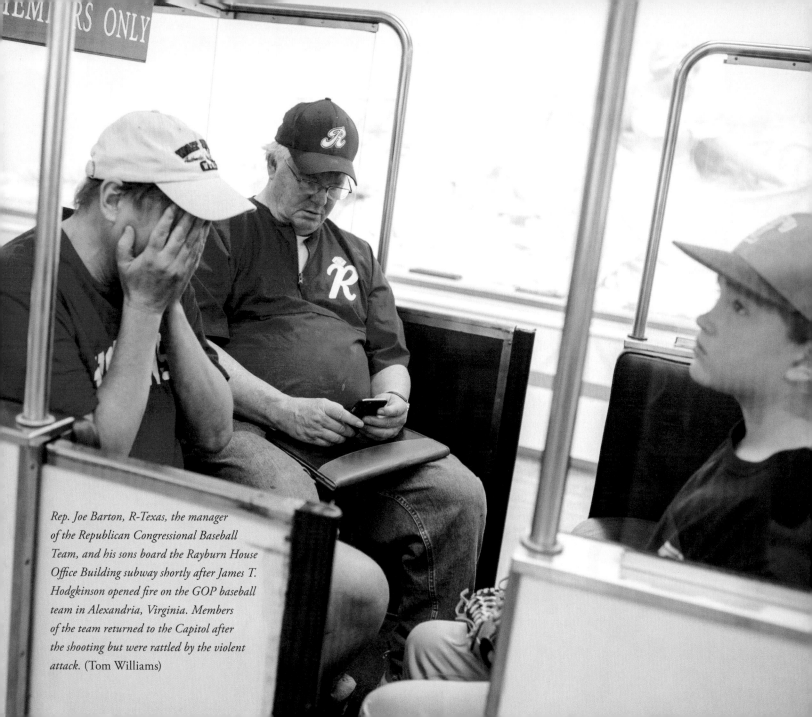

MEMBERS ONLY

Rep. Joe Barton, R-Texas, the manager of the Republican Congressional Baseball Team, and his sons board the Rayburn House Office Building subway shortly after James T. Hodgkinson opened fire on the GOP baseball team in Alexandria, Virginia. Members of the team returned to the Capitol after the shooting but were rattled by the violent attack. (Tom Williams)

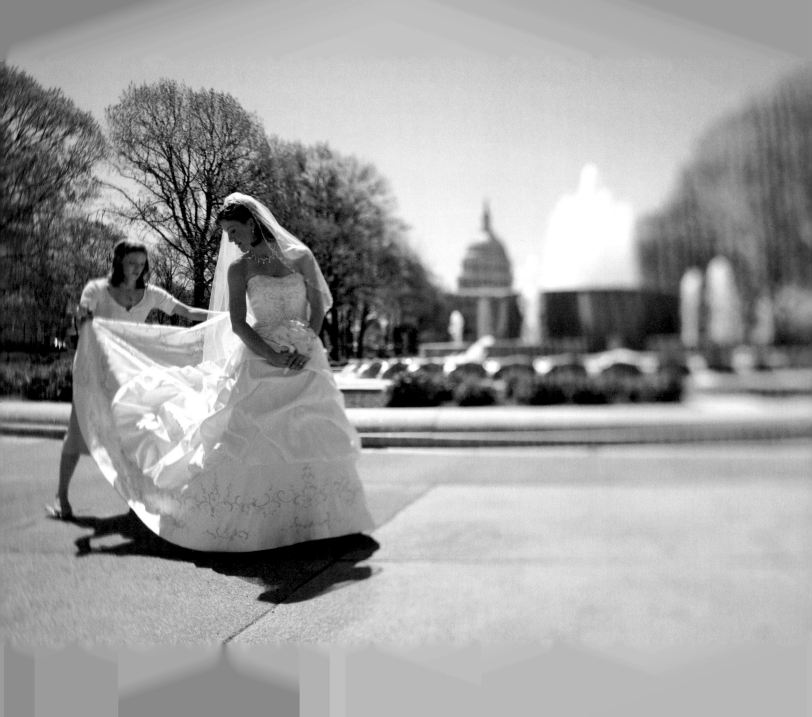

Love

Washington's image can be stuffy.

Maybe it's the marble. The ranks of conservatively dressed politicians in blue suits and dresses. The military presence. The security bollards.

And few places symbolize Washington as much as the Capitol building, the teeming center of the legislative branch, where the people's business gets a vigorous workout amid more than two hundred years of history.

So perhaps it's odd to think that love is present in such a place of brisk, or grinding, business.

But then there is a young couple, both elected members of Congress and from opposite sides of the country, canoodling.

There's one of the Supreme Court's most famous jurists holding tight for a hug with the president of the United States.

There is the Speaker of the House walking with his children, casually making their way, as a family, to a reception after he was sworn in.

And don't tell those brides and grooms getting their wedding photos taken with the Capitol as a backdrop that there is no romance to the place.

Love is in the air, even under the Dome of the Capitol.

★ ★

Amanda Dale of Dallas helps arrange the wedding dress of her sister, Elisa Harvey, of Falls Church, Virginia, before taking photos in Upper Senate Park, with the Capitol Dome in the background. (Bill Clark)

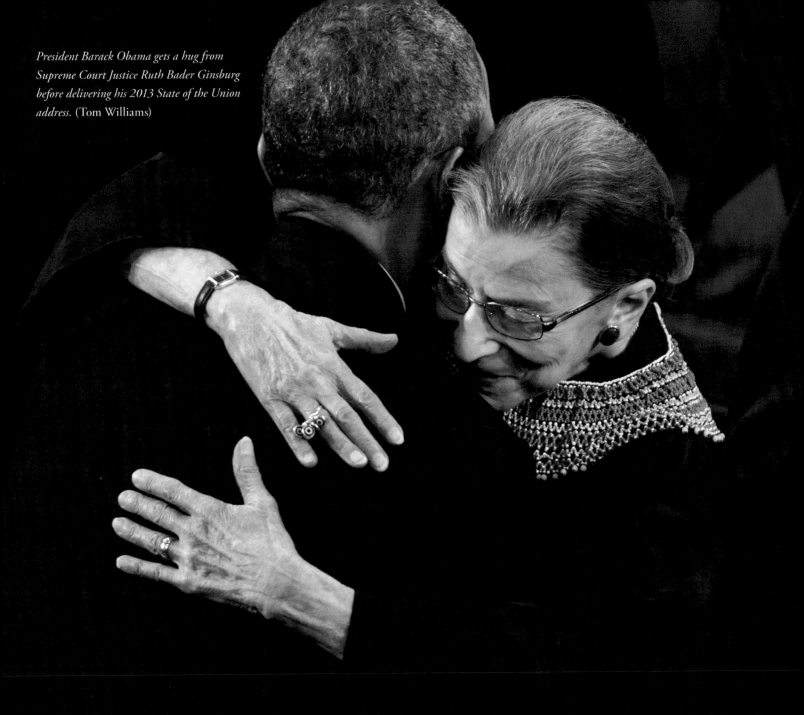

President Barack Obama gets a hug from Supreme Court Justice Ruth Bader Ginsburg before delivering his 2013 State of the Union address. (Tom Williams)

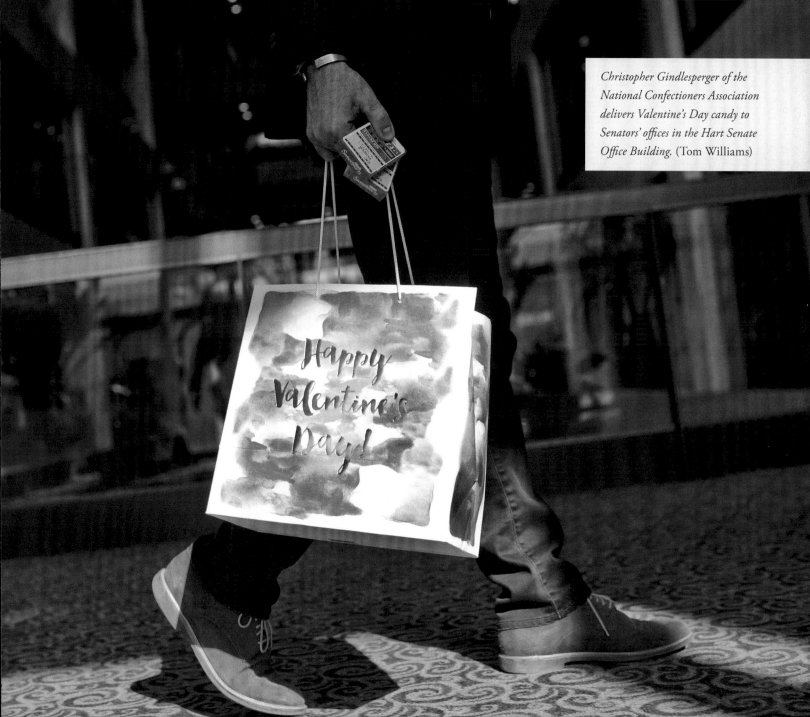

Christopher Gindlesperger of the National Confectioners Association delivers Valentine's Day candy to Senators' offices in the Hart Senate Office Building. (Tom Williams)

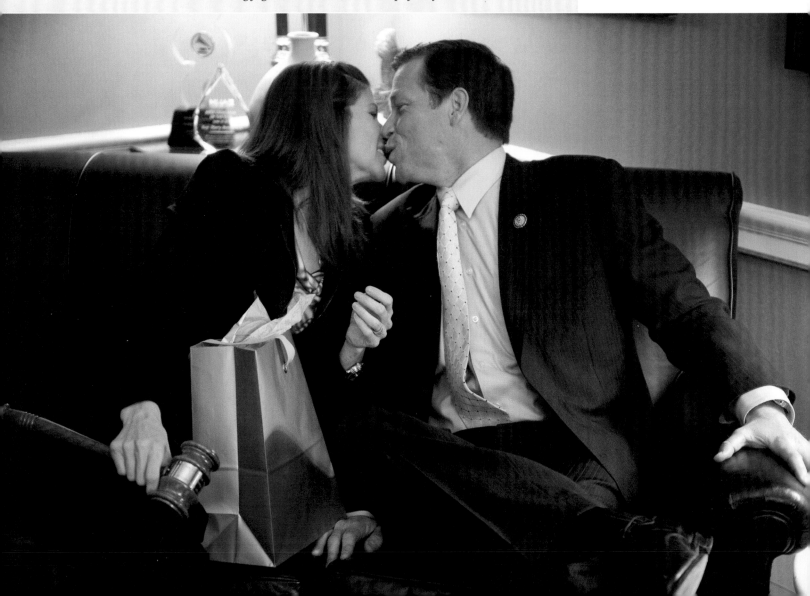

Rep. Mary Bono Mack, R-Calif., kisses her husband, Rep. Connie Mack, R-Fla., after he surprised her with a gift gavel to note her chairmanship of a key subcommittee. (Bill Clark)

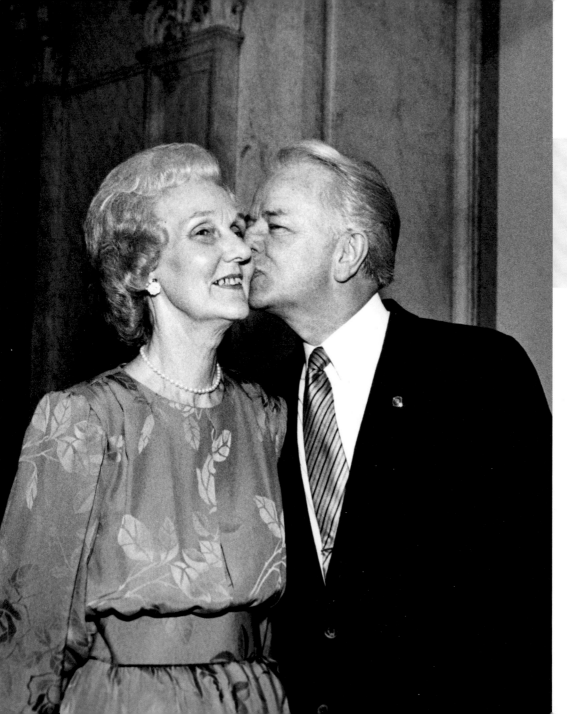

Sen. Robert Byrd, the West Virginia Democrat who served longer in the Senate than anyone in history, kisses his wife Erma James.
(CQ Roll Call)

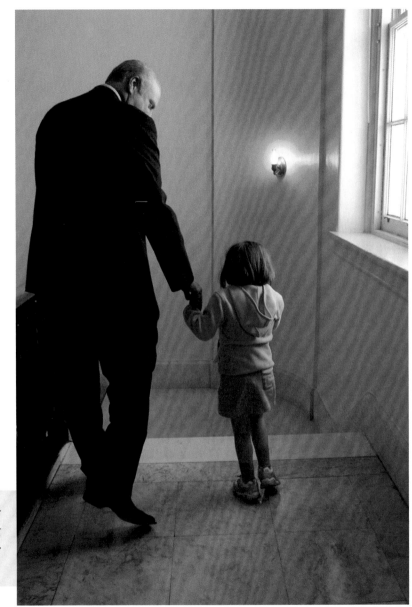

Rep. Joe Crowley, D-N.Y., walks down the hallway of the Cannon House Office Building with his daughter, Kenzie Louise, on Take Your Child to Work Day. (Tom Williams)

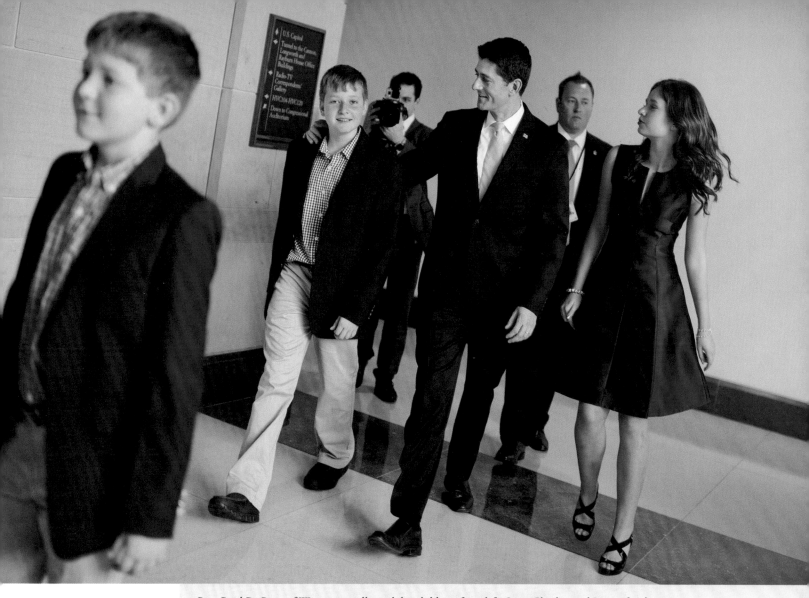

Rep. Paul D. Ryan of Wisconsin walks with his children, from left, Sam, Charlie, and Liza, after being sworn in on the House floor as the fifty-fourth Speaker of the House. (Tom Williams)

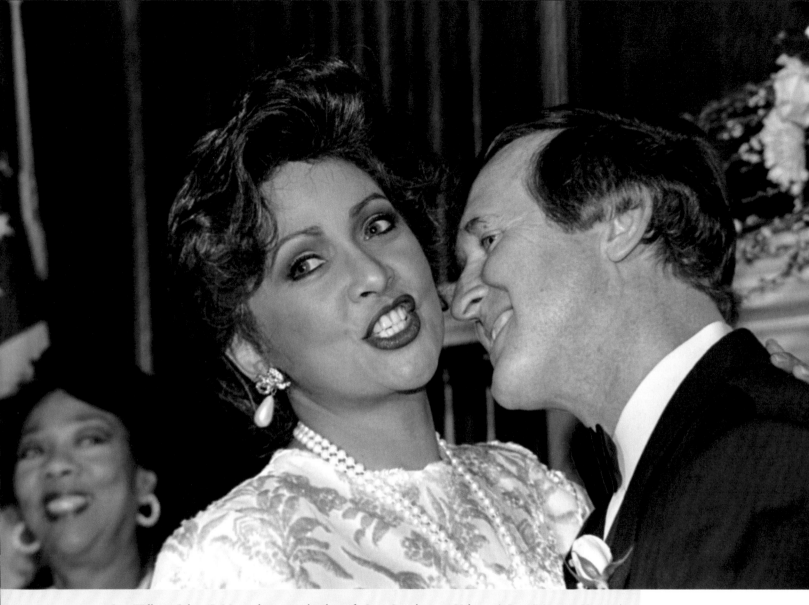

Sen. William Cohen, R-Maine, leans in to kiss his wife, Janet Langhart, on Valentine's Day. (Maureen Keating)

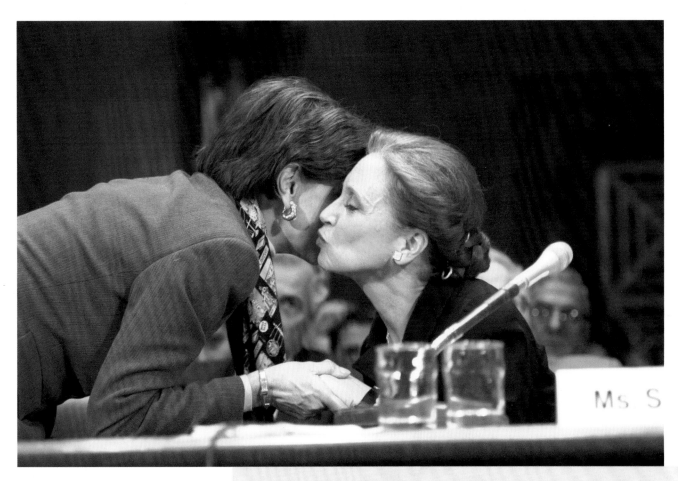

Romance novelist Danielle Steel kisses Rep. Nancy Pelosi, D-Calif., after testifying before a congressional panel on her son Nick Traina's struggle with mental illness, which was the focus of a book Steel wrote, His Bright Light. *(Ian Wagreich)*

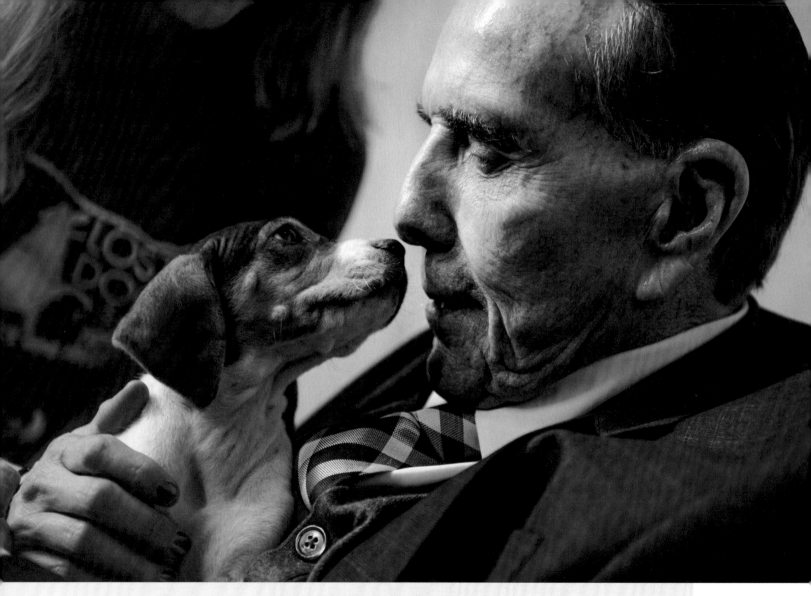

Sen. Bob Dole greets a beagle mix puppy during the annual "Paws for Love" adoption event on Capitol Hill. (Tom Williams)

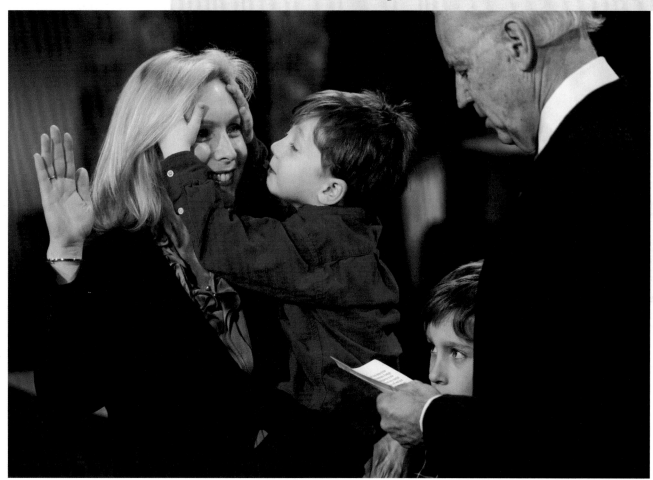

Sen. Kirsten Gillibrand, D.-N.Y., raises her right hand as her son Henry messes up her hair while Vice President Joe Biden delivers the ceremonial swearing in in the Old Senate Chamber. Her other son, Theodore, lower right, looks on. (Bill Clark)

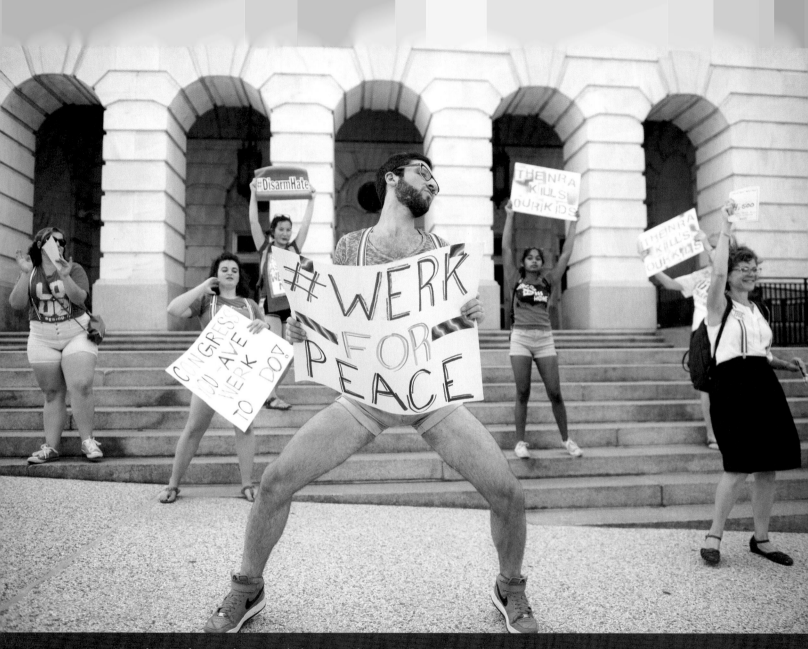

Firas Nasr of WERK for Peace dances outside the Longworth House Office Building to bring attention to deaths by gun violence. (Tom Williams)

Disapproval

There are many ways to disapprove of something, or someone.

One might only look to the Capitol for a hint of these many ways.

If you are a dancer, you might bust a few moves to protest gun violence.

Not your style?

There is always occupying the public space of the Capitol, perhaps with photographs of loved ones, to protest that same gun violence. One may stand, sit, lie on the floor.

Of course, this might mean Capitol Police will disapprove of your actions, even if the right to protest is protected by the Constitution.

Lots of people use signs.

Using humor is a good way to signal disapproval.

Dress up like Rich Uncle Pennybags to protest the head of a financial firm you think might be ripping you off.

Bring bloodhounds to go find missing legislation. The slobber will make the point for you.

Sometimes disapproval is more subtle.

It can be a look.

It can be a wince, especially after people, maybe even your own peers, find a way to disapprove of you.

Everyone likes approval.

Disapproval?

That's another story, and it's told over and over again.

★ ★

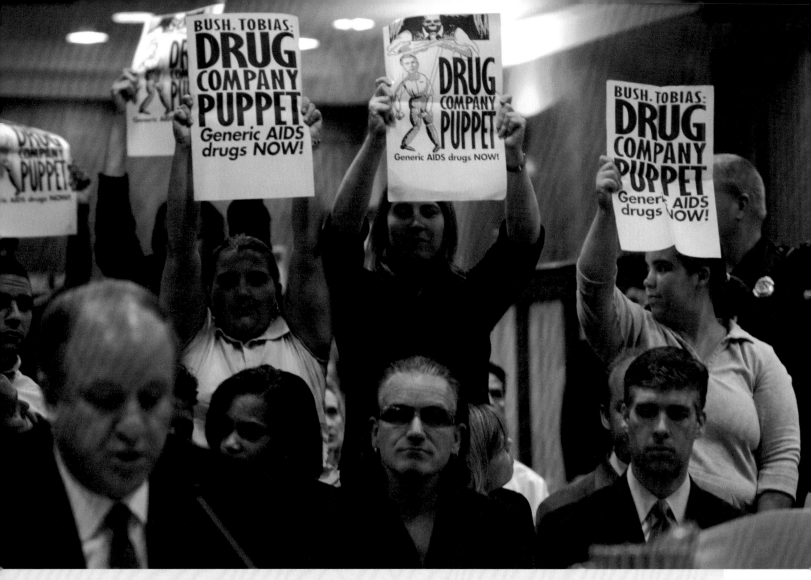

Health GAP demonstrators hold up signs promoting generic AIDS medication as Randall Tobias, the government's HIV/AIDS coordinator, testifies. U2 Singer Bono (with sunglasses) sits behind him. Bono founded the group DATA (Debt, AIDS, Trade, Africa). (Chris Maddaloni)

Capitol Police clear tourists and the media in the Rotunda before arresting families and friends of gun violence victims who were protesting congressional inaction on gun safety legislation. (Bill Clark)

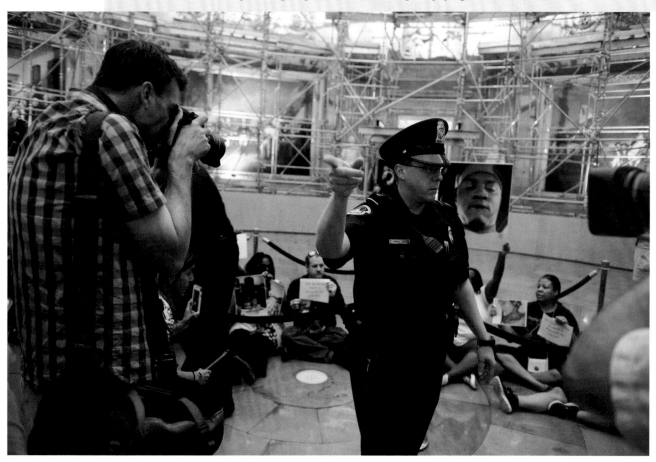

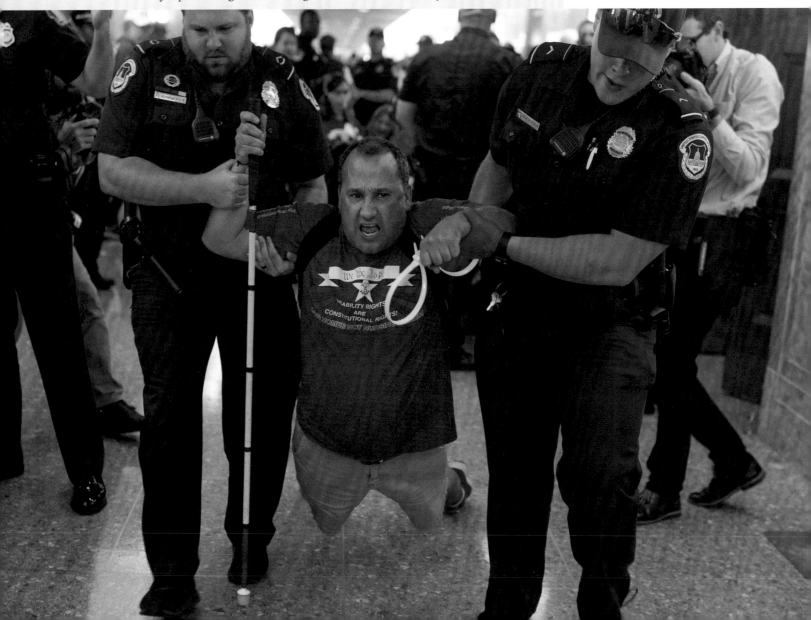

Capitol Police carry out a man protesting proposed cuts to disability benefits that would be part of Republican legislation to change the U.S. health insurance system. (Tom Williams)

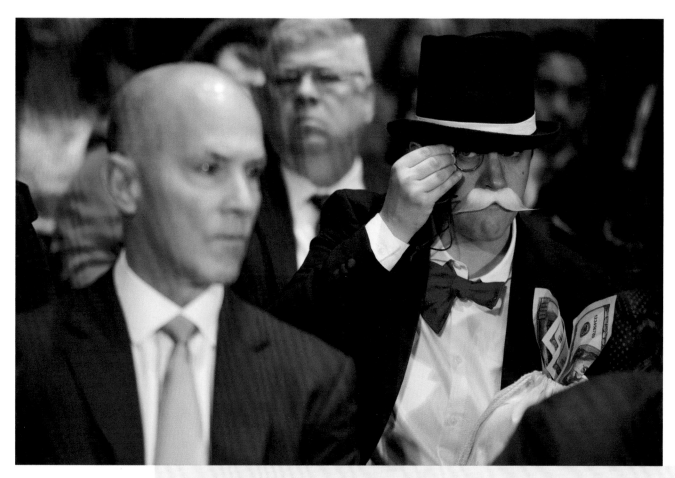

Amanda Werner, dressed as the board game Monopoly's Rich Uncle Pennybags, sits behind Richard Smith, CEO of Equifax, during a hearing on the Equifax data breach. (Tom Williams)

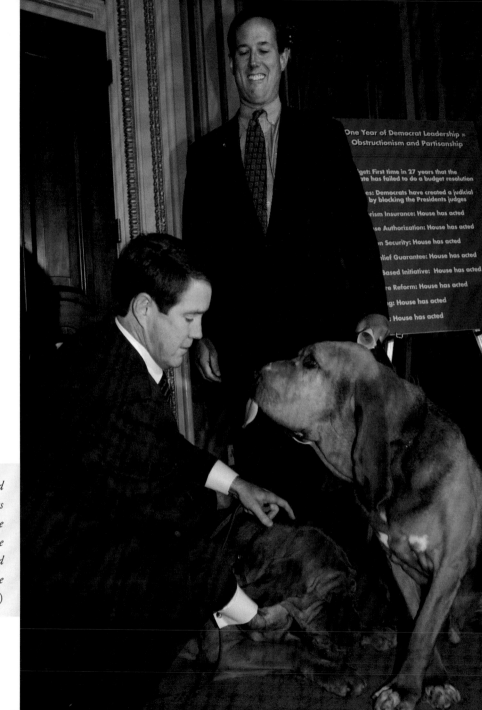

One Year of Democrat Leadership =
Obstructionism and Partisanship

...get: First time in 27 years that the
...ate has failed to do a budget resolution

...es: Democrats have created a judicial
...by blocking the Presidents judges

...rism Insurance: House has acted

...se Authorization: House has acted

...n Security: House has acted

...lief Guarantee: House has acted

...Based Initiative: House has acted

...re Reform: House has acted

...g: House has acted

...: House has acted

Sen. Bill Frist, R-Tenn., squatting, and Sen. Rick Santorum, R-Pa., at a press conference where they criticized the majority party Democrats' legislative agenda by asking bloodhounds to find legislation that had not yet come to the Senate. (Scott J. Ferrell)

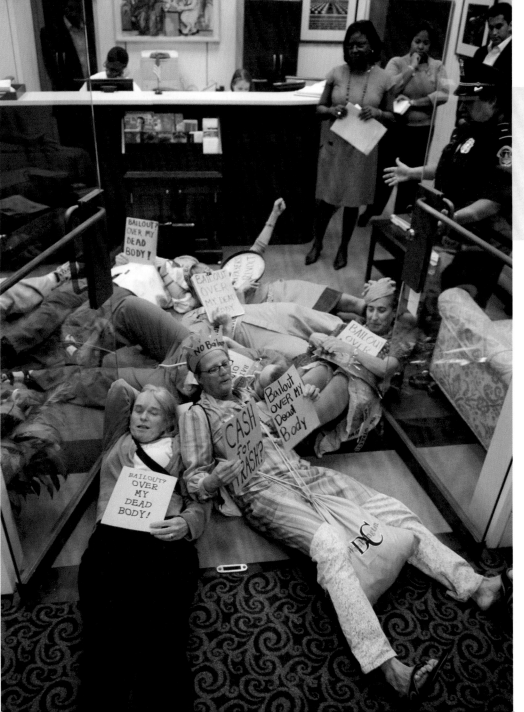

Members of CodePink stage a die-in at the office of Sen. Barack Obama, D-Ill., to protest legislation that would bail out the financial sector during the stock market swoon. (Bill Clark)

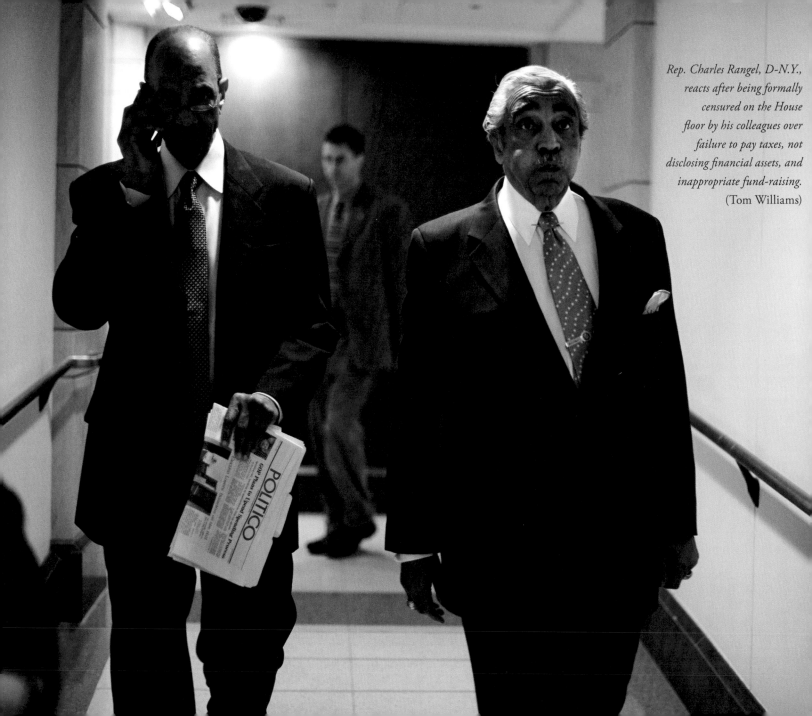

Rep. Charles Rangel, D-N.Y., reacts after being formally censured on the House floor by his colleagues over failure to pay taxes, not disclosing financial assets, and inappropriate fund-raising. (Tom Williams)

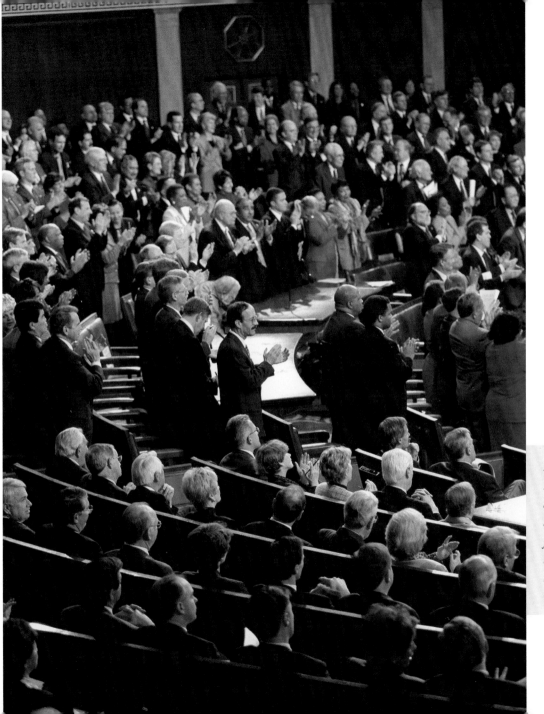

Democrats applaud while Republicans remain seated during President Bill Clinton's State of the Union in 1999, just a few hours after the Senate's impeachment trial of Clinton began. (Douglas Graham)

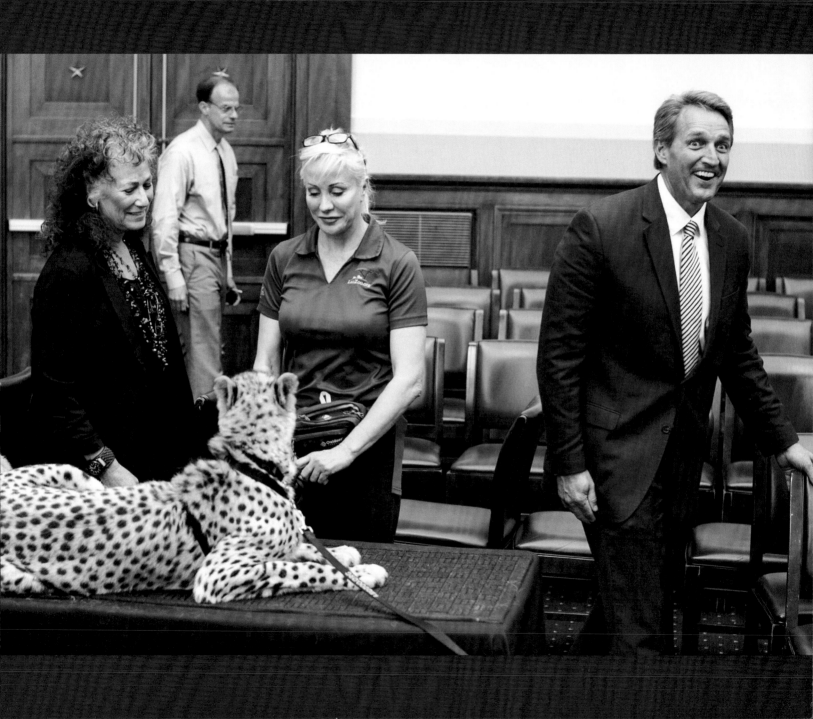

CHAPTER 14

Surprise

Surprise!

It's not just for birthday parties anymore.

It's the feeling of being caught off guard, or coming across something wholly unexpected.

Perhaps it's a cheetah in a hearing room.

Maybe a senior congressional aide dancing in the Rotunda of the Capitol, surrounded by visitors wondering what is up with the lady in red so close to the ground there.

It may surprise you to know senators have hideaway offices in the Capitol, and they are as quirky and individual as the Senate chamber is formal and uniform.

Sen. Robert Byrd pretty much knew everything you needed to know as a senator, until one day he forgot the lines to the oath of office, among the most familiar lines he knew in several decades of swearing in new senators.

There is the surprise of things not quite going your way, like when your boss loses a political race that should have been an easy one.

The shock of something happening that wasn't supposed to.

It happens all the time.

★ ★

Sen. Jeff Flake, R-Ariz., walks away after meeting Adaeze the cheetah after a briefing for senators about threats to the African big cat. (Al Drago)

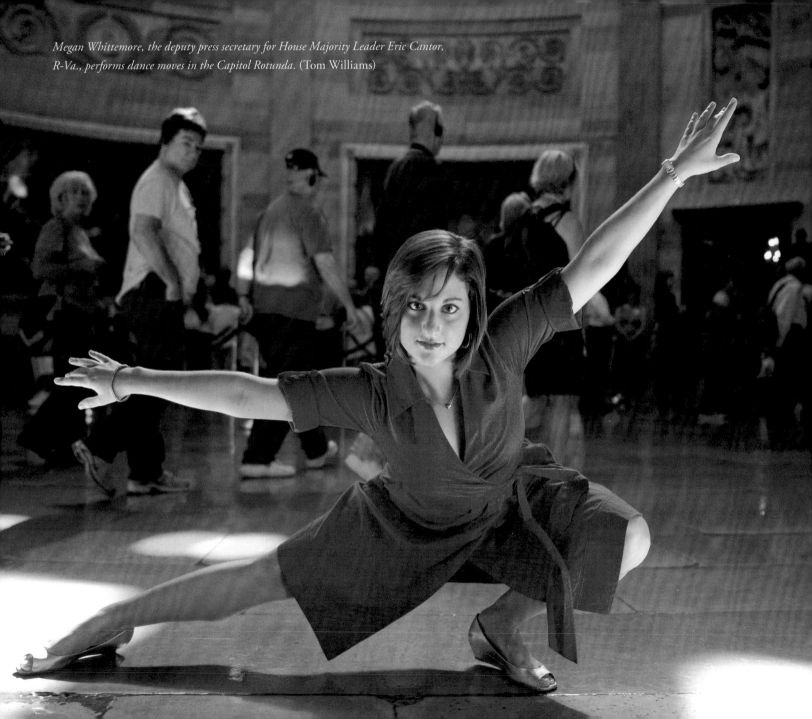

Megan Whittemore, the deputy press secretary for House Majority Leader Eric Cantor, R-Va., performs dance moves in the Capitol Rotunda. (Tom Williams)

Sen. Mark Udall, D-Colo., leans in to get a good look at the volcano cake that his legislative assistant Wendy Adams made. Adams made the cake to commemorate the May 18, 1980, eruption of Mount Saint Helens. The cake featured smoke created by dry ice, a mud slide of chocolate and strawberries, pretzel stick trees, and gummy bears that stood in for the fleeing animals. (Bill Clark)

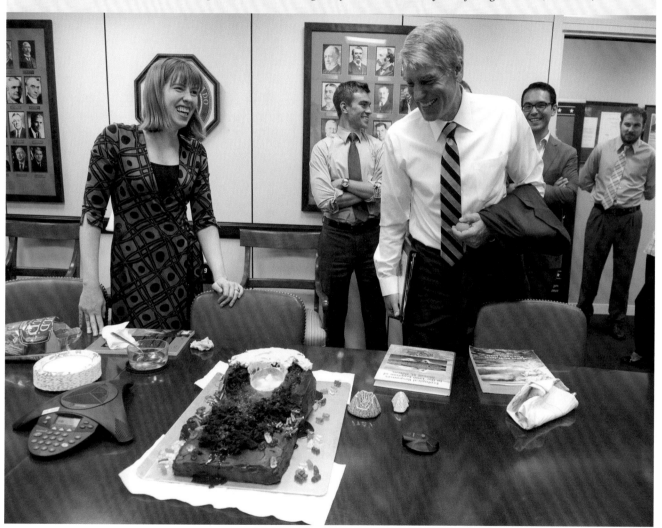

Sen. Robert Byrd, D-W. Va., the Senate President Pro Tempore, pauses to take out his notes after forgetting his lines at a mock swearing in for Tennessee Republican Fred Dalton Thompson in the Old Senate Chamber. Byrd was a stickler for the chamber's traditions and rules, and Thompson was a long-time actor and one-time congressional aide, so the moment was an unexpected one for both men. (Chris Martin)

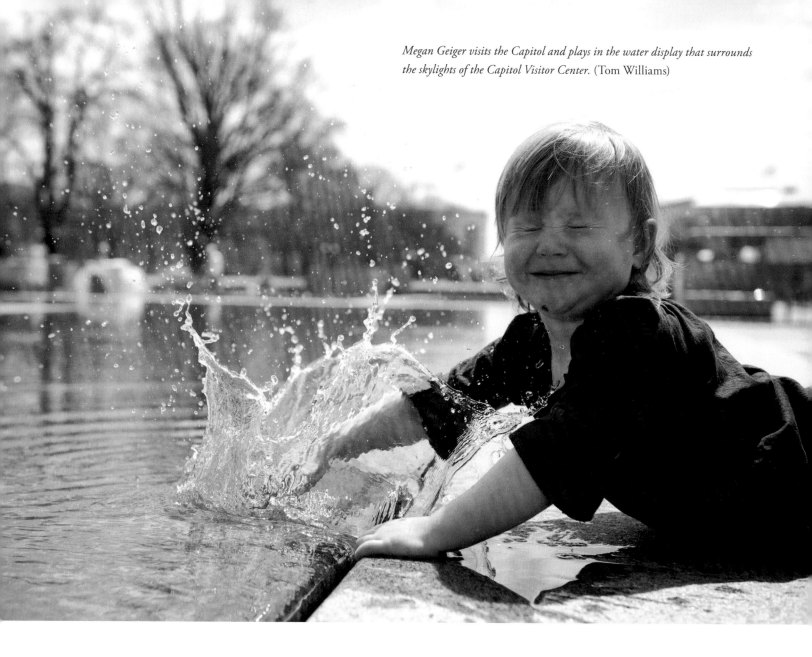

Megan Geiger visits the Capitol and plays in the water display that surrounds the skylights of the Capitol Visitor Center. (Tom Williams)

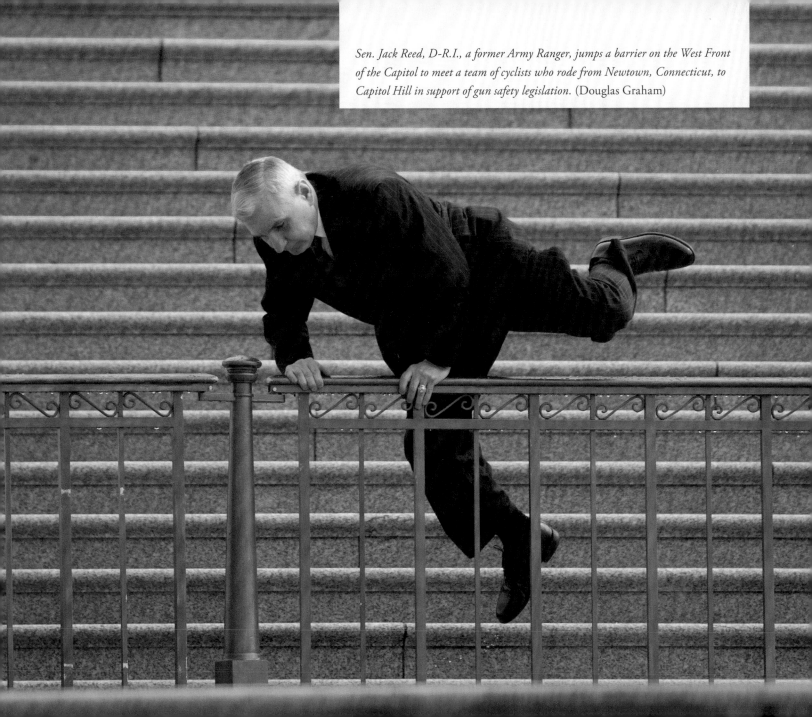

Sen. Jack Reed, D-R.I., a former Army Ranger, jumps a barrier on the West Front of the Capitol to meet a team of cyclists who rode from Newtown, Connecticut, to Capitol Hill in support of gun safety legislation. (Douglas Graham)

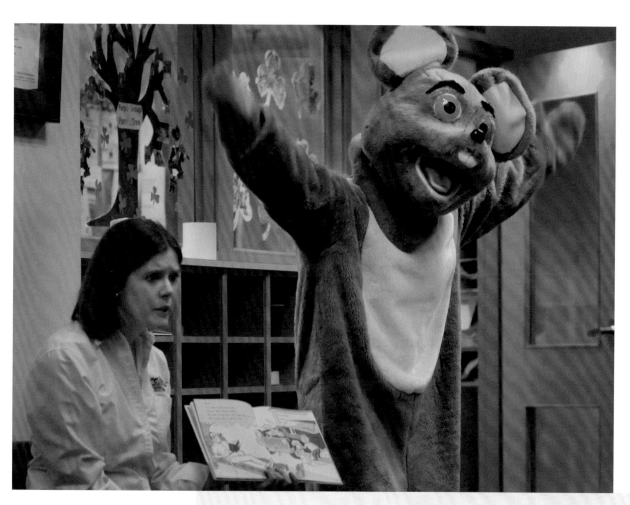

Brandi Duncan and the House Mouse entertain children at the Ford House Office Building Day Care Center by reading and acting out Dr. Seuss. (Chris Maddaloni)

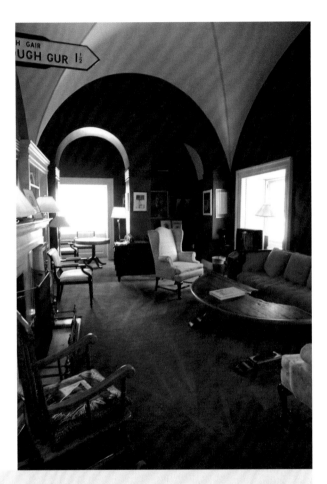

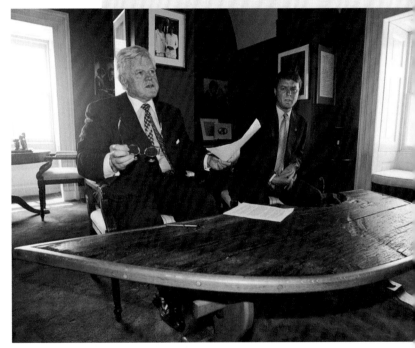

Sen. Edward M. Kennedy, D-Mass., and Sen. John Edwards, D.-N.C., discuss health care legislation in Kennedy's Capitol hideaway. (Scott J. Ferrell)

The hideaway of Sen. Edward Kennedy, D-Mass., provided a cozy respite for the senator and his guests in the middle of the Capitol building. (Douglas Graham)

Katie Patru stands outside a news conference in the Capitol as her boss, House Majority Leader Eric Cantor, R-Va., announces he will step down from his post. Cantor had just unexpectedly lost his primary race. (Tom Williams)

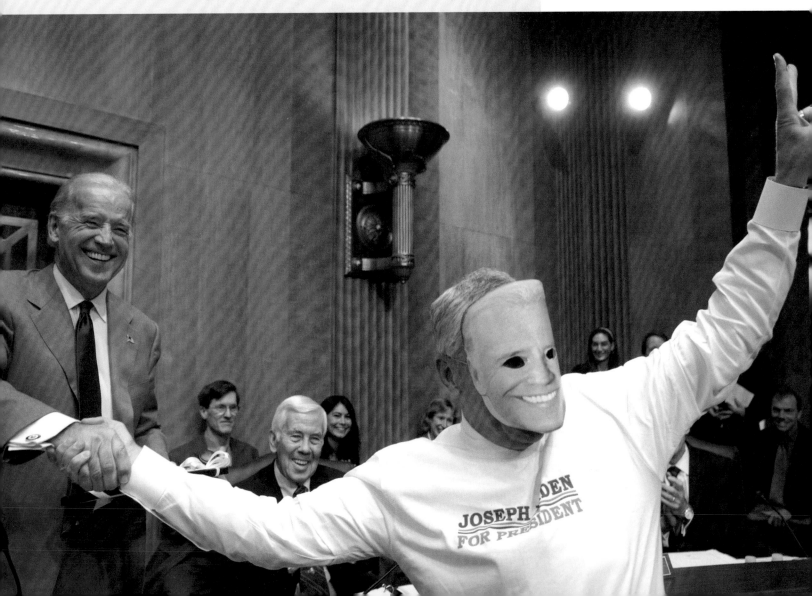

Sen. Joe Biden, D-Del., laughs as Sen. Chuck Hagel, R-Neb., dressed up as Biden, crashed a meeting of the Foreign Relations Committee on Halloween Day. (Bill Clark)

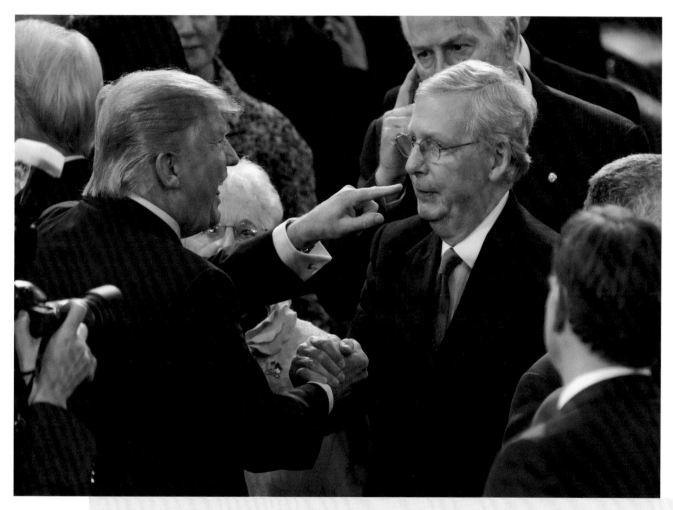

President Donald Trump shakes hands with and points at Senate Majority Leader Mitch McConnell, R-Ky., after Trump delivered his address to a joint session of Congress. Most members of the Republican establishment, especially McConnell, did not expect Trump to win the presidency. (Bill Clark)

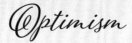

CHAPTER 15

Optimism

Thumbs up.

Is there a more universal sign for optimism, the feeling that things are going to turn out just fine?

It's part of the human condition, feeling hopeful and confident about the future, that things will turn out for the better.

Sometimes that optimism comes after a bitter struggle, and victory, like after an election.

Sometimes it's because there is a turning point in history, like the election of the first woman Speaker of the House, and everyone knows it's a big deal.

Sometimes it can be misplaced, like when you think something, or someone, will turn out OK, and it doesn't, like legislation or programs that get unwound.

Everything comes to an end—terms of office, political movements, a politician's connection to his or her constituents.

But that doesn't stop people from hoping, from believing, that things will be good. That's the whole point of the country, really, at least as the Founding Fathers hoped, yes, hoped it would be.

That the people would form a more perfect union.

It's right there in the Preamble of the Constitution.

The only thing missing is a thumbs up.

★ ★

Rep. Janice Hahn, D-Calif., at her mock swearing in with her son-in-law John Yates. (Scott J. Ferrell)

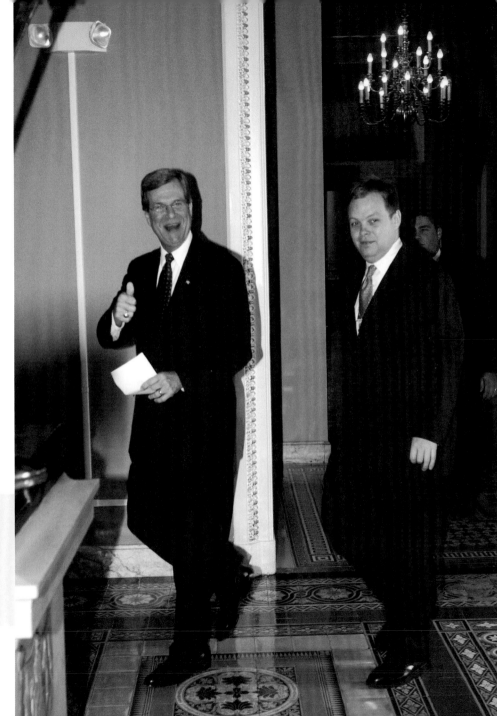

Sen. Trent Lott, R-Miss., is pleased with the election results in November 2002, when his party won enough seats to take over the majority in the Senate.
(Scott J. Ferrell)

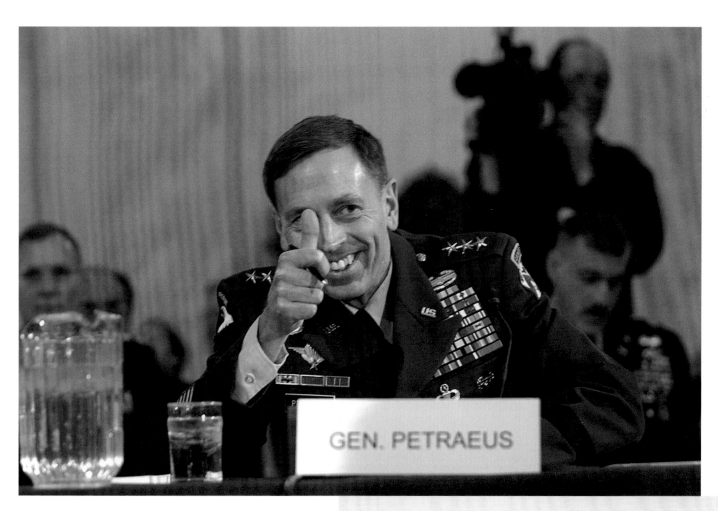

Army Lt. Gen. David Petraeus at his Senate confirmation hearing to be commander of the multinational forces in Iraq. (Barbara L. Salisbury)

Senate Majority Leader Mitch McConnell, R-Ky., celebrates after changing Senate rules and tradition to allow a simple majority vote to advance and confirm Neil Gorsuch to the Supreme Court. (Tom Williams)

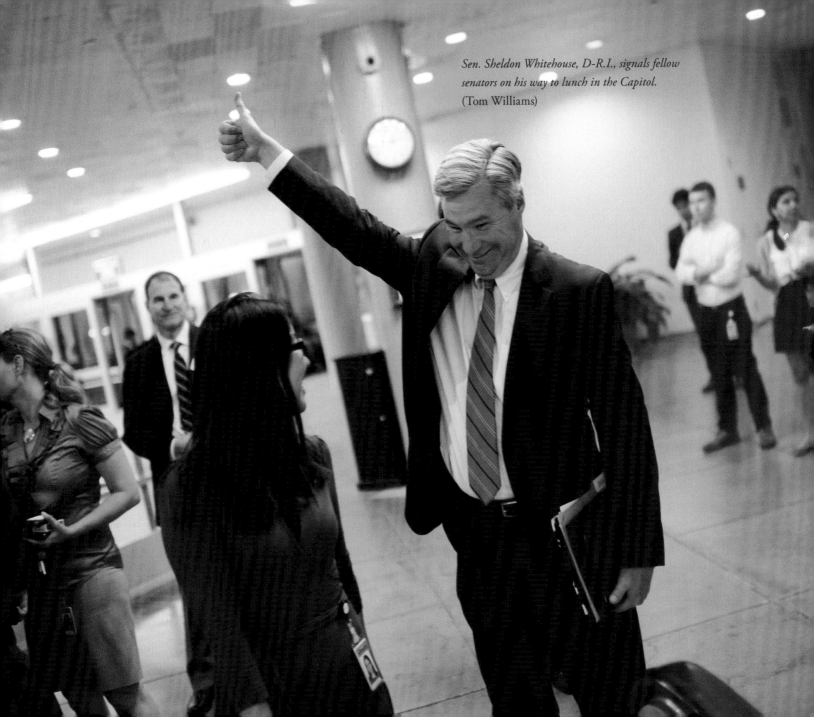

Sen. Sheldon Whitehouse, D-R.I., signals fellow senators on his way to lunch in the Capitol.
(Tom Williams)

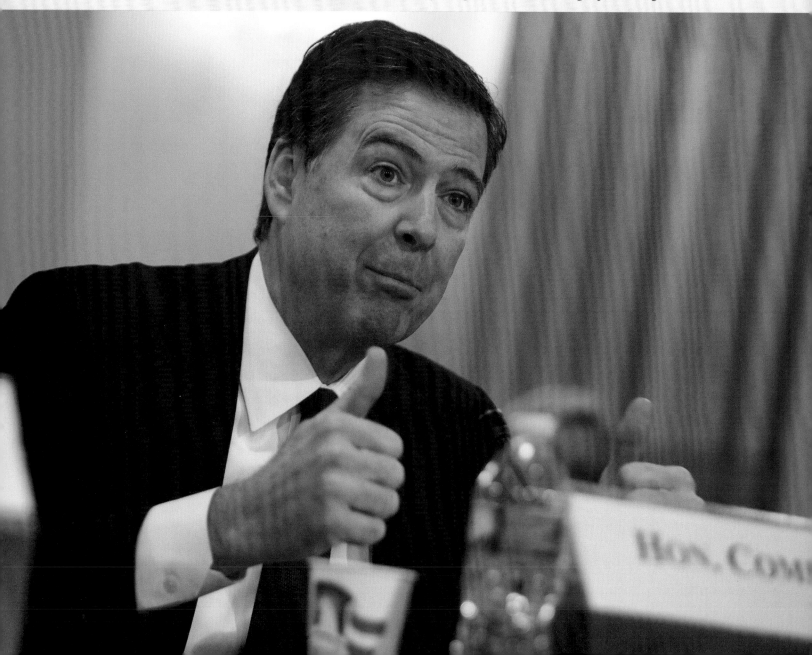

FBI Director James Comey testifying about the bureau's efforts against extremist terrorist groups. (Al Drago)

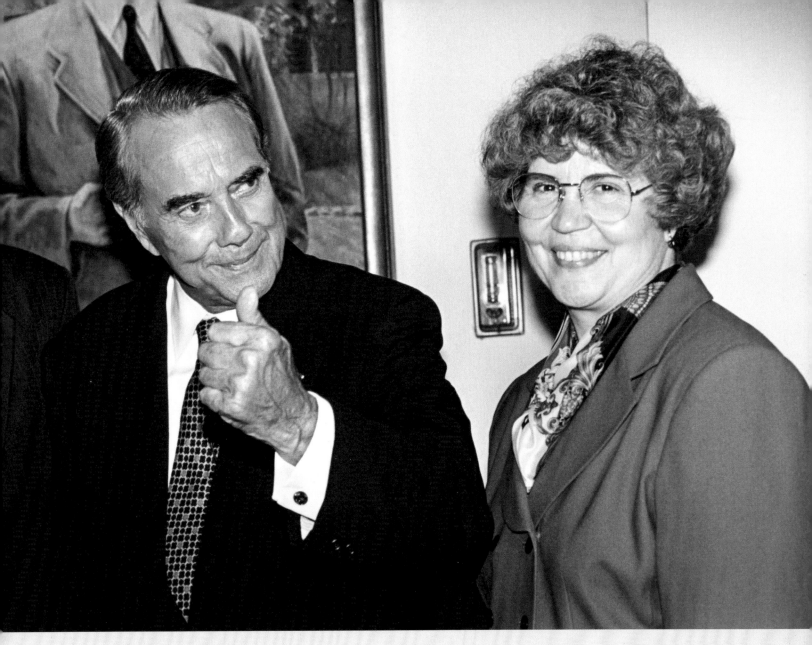

Sen. Bob Dole, R-Kan., on his last day in office as he turns over his seat to his successor, Sen. Sheila Sloan Frahm, R-Kan. (Maureen Keating)

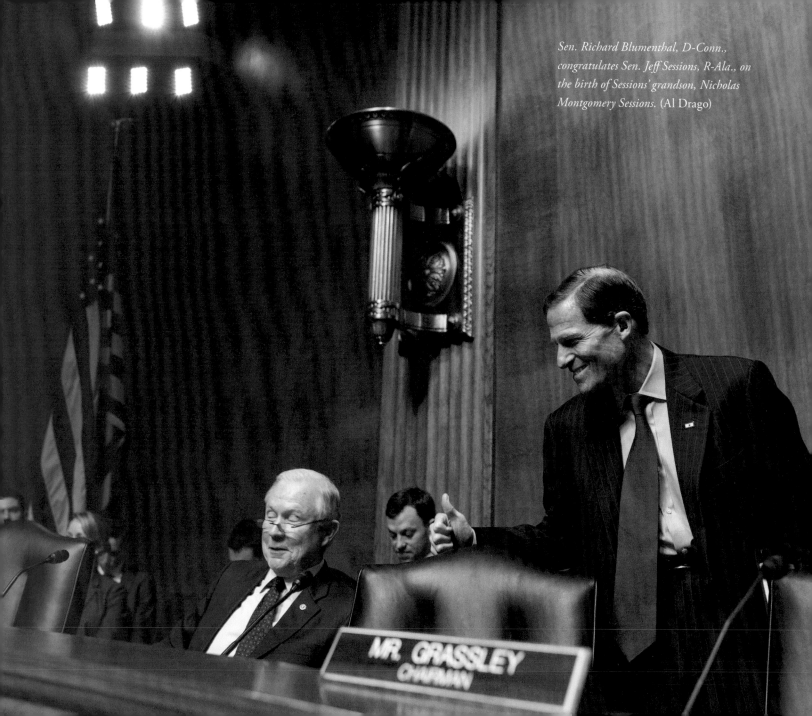

MR. GRASSLEY
CHAIRMAN

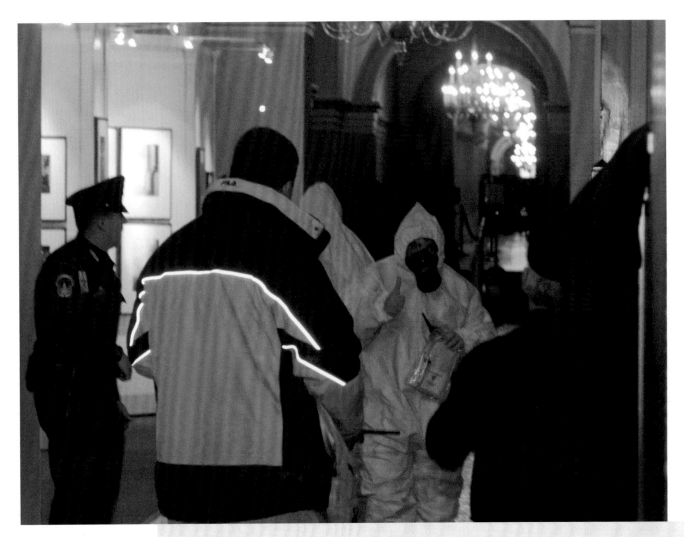

Capitol Police in hazardous materials suits signal that the Capitol is clear of the deadly toxin ricin, which was detected in a Senate mailroom. (Chris Maddaloni)

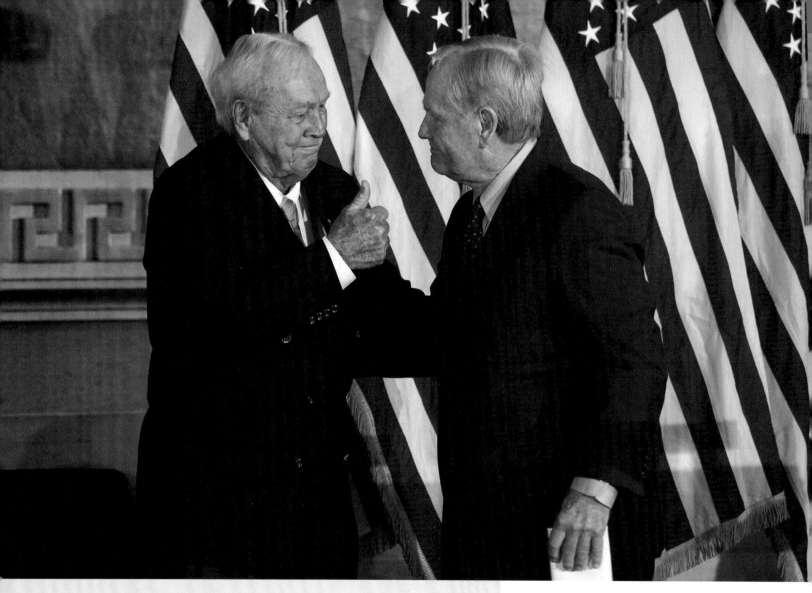

Golf legend Arnold Palmer, left, signals his approval to fellow legend Jack Nicklaus after Palmer was awarded the Congressional Gold Medal. (Chris Maddaloni)

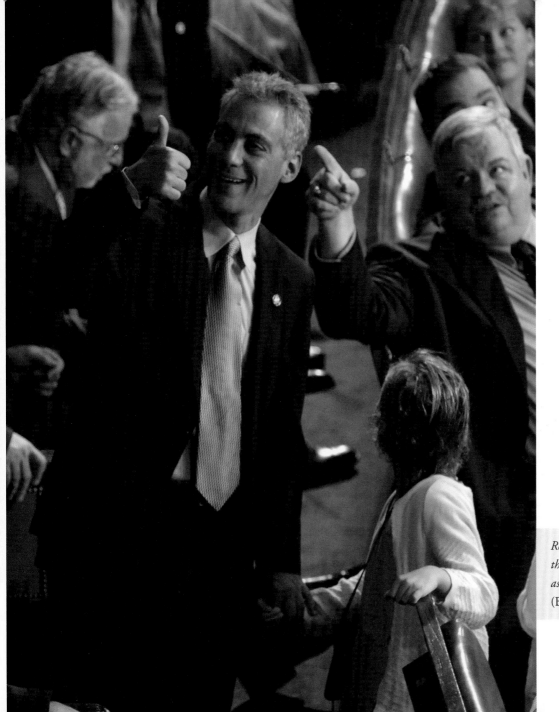

Rep. Rahm Emanuel, D-Ill., gestures to the gallery after Nancy Pelosi is sworn in as the first woman Speaker of the House. (Bill Clark)

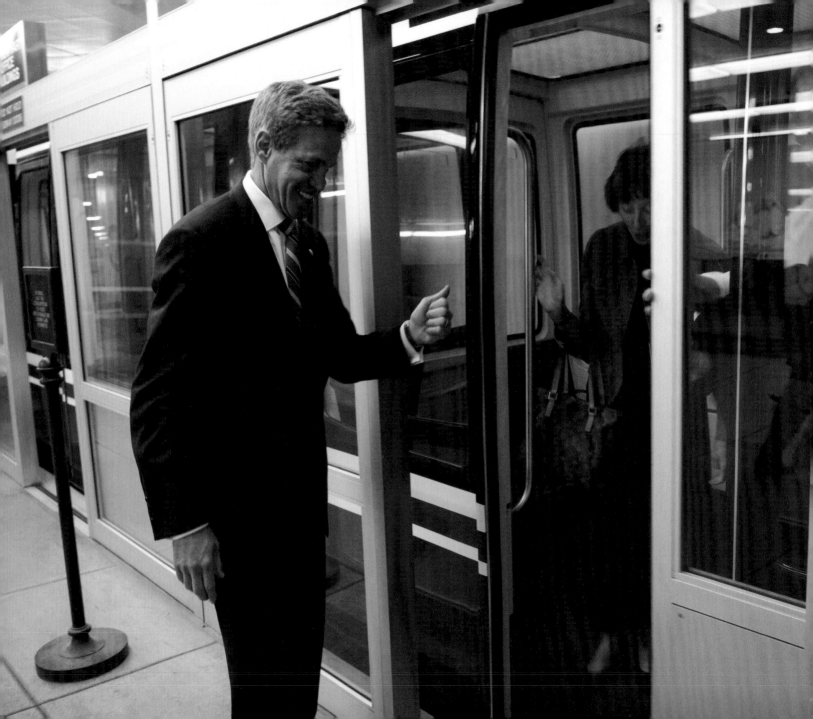

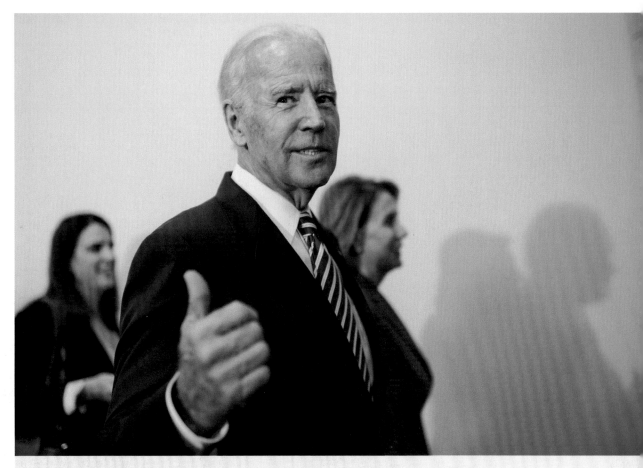

Sen. Norm Coleman, R-Minn., helps trapped passengers pry open the doors of the Senate subway. (Bill Clark)

Vice President Joe Biden after briefing House Democrats about the administration's negotiations on the Iran nuclear deal. (Tom Williams)

The United States Capitol Dome is more than 150 years old, 287 feet tall, and weighs 8.9 million pounds. That's an old, big structure, responsible for holding together a place where people work, visit, and sometimes abuse it.

Its job as a symbol is perhaps bigger.

More than anything else, the Dome, sitting atop the seat of government in the capital city, says "America" to the world. And it is under that Dome that the world's citizens, not just Americans, see the work in progress that the country constructs on a daily basis.

It hosts soaring moments that showcase the very best that humans can be.

It is witness to the most humble, lowly, and base parts of our character as well.

Out of these snapshots in time, I hope there appears a snapshot not just of life in Congress, in the Capitol, but a reflection of human nature, of ritual, of feeling.

Just from my own news organization's archives, there are hundreds of thousands of photographs capturing every conceivable moment we could in this unique space. That is a lot of material to work with, and these pictures are but a representative few.

I've only worked at Roll Call for a short portion of its long history, but in that times I have been amazed by the incredible journalism of the photographers I've called my colleagues: Bill Clark, Al Drago, Douglas Graham, Chris Maddaloni, and Tom Williams. And they follow in the footsteps of the photographers who were there at the beginning to set the stage.

Congress, its visitors, celebrities, protesters, athletes, dignitaries pass through here at a dizzying pace. It is easy to miss things.

I hope this volume has made it a little easier to catch up, reflect, and be delighted about what goes on under the Dome.